T0275891

The Emancipated Spectator

JACQUES RANCIÈRE is Emeritus Professor of Philosophy at the University of Paris-VIII. His books include *The Future of the Image*, *Hatred of Democracy*, *The Politics of Aesthetics*, *On the Shores of Politics*, and *Proletarian Nights*.

The Emancipated Spectator

JACQUES RANCIÈRE

Translated by Gregory Elliott

VERSO

London • New York

First English edition published by Verso 2009
This paperback edition published by Verso 2011
© Verso 2011
Translation © Gregory Elliott 2009
First published as *Le Spectateur émancipé*
© Editions La Fabrique 2008

1 3 5 7 9 10 8 6 4 2

Verso
UK: 6 Meard Street, London W1F 0EG
US: 20 Jay Street, Suite 1010, Brooklyn, NY 11201
www.versobooks.com

Verso is the imprint of New Left Books

ISBN-13: 978-1-84467-761-0

British Library Cataloguing in Publication Data
A catalogue record for this book is available from the British Library

Library of Congress Cataloging-in-Publication Data
A catalog record for this book is available from the Library of Congress

Typeset by MJ Gavan, Truro, Cornwall
Printed in the United States

Contents

1 The Emancipated Spectator 1

2 The Misadventures of Critical Thought 25

3 Aesthetic Separation, Aesthetic Community 51

4 The Intolerable Image 83

5 The Pensive Image 107

 Acknowledgements 133

1

The Emancipated Spectator

This book originated in a request I received a few years ago
to introduce the reflections of an academy of artists on the
spectator, on the basis of ideas developed in my book *The
Ignorant Schoolmaster*.[1] The proposal initially caused me some
bewilderment. *The Ignorant Schoolmaster* set out the eccen-
tric theory and singular fate of Joseph Jacotot, who created a
scandal in the early nineteenth century by claiming that one
ignoramus could teach another what he himself did not know,
asserting the equality of intelligence and opposing intellectual
emancipation to popular instruction. His ideas had fallen into
oblivion in the middle of his century. I had thought it worth-
while reviving them in the 1980s, to inject some life into
debates on the purposes of public education by throwing in
the issue of intellectual equality. But how was the thought of
a man whose artistic universe can be emblematized by the
names of Demosthenes, Racine and Poussin relevant to con-
temporary thinking about art?

On reflection, it seemed to me that the absence of any
obvious relationship between the theory of intellectual eman-
cipation and the question of the spectator today was also an

1 The invitation to open the fifth Internationale Sommerakademie of
 Frankfurt-on-Main, on 20 August 2004, came from the Swedish
 performer and choreographer Mårten Spångberg.

opportunity. It might afford an occasion for a radical differentiation from the theoretical and political presuppositions which, even in postmodern form, still underpin the gist of the debate on theatre, performance and the spectator. But in order to bring out the relationship and make it meaningful, it was necessary to reconstruct the network of presuppositions that place the question of the spectator at the heart of the discussion of the relations between art and politics. It was necessary to outline the general model of rationality against whose background we have become used to judging the political implications of theatrical spectacle. I use this term here to include all those forms of spectacle – drama, dance, performance art, mime and so on – that place bodies in action before an assembled audience.

The numerous critiques for which theatre has provided the material throughout its history can in effect be boiled down to one basic formula. I shall call it the paradox of the spectator – a paradox that is possibly more fundamental than the famous paradox of the actor. This paradox is easily formulated: there is no theatre without a spectator (if only a single, concealed spectator, as in the fictional performance of *Le Fils naturel* that gives rise to Diderot's *Entretiens*). But according to the accusers, being a spectator is a bad thing for two reasons. First, viewing is the opposite of knowing: the spectator is held before an appearance in a state of ignorance about the process of production of this appearance and about the reality it conceals. Second, it is the opposite of acting: the spectator remains immobile in her seat, passive. To be a spectator is to be separated from both the capacity to know and the power to act.

This diagnosis leads to two different conclusions. The first is that theatre is an absolutely bad thing: a scene of illusion and passivity that must be abolished in favour of what it prohibits –

knowledge and action; the action of knowing and action guided by knowledge. This is the conclusion formulated by Plato: theatre is the place where ignoramuses are invited to see people suffering. What the theatrical scene offers them is the spectacle of a *pathos*, the manifestation of an illness, that of desire and suffering – that is to say, the self-division which derives from ignorance. The particular effect of theatre is to transmit this illness by means of another one: the illness of the gaze in thrall to shades. It transmits the illness of ignorance that makes the characters suffer through a machinery of ignorance, the optical machinery that prepares the gaze for illusion and passivity. A true community is therefore one that does not tolerate theatrical mediation; one in which the measure that governs the community is directly incorporated into the living attitudes of its members.

That is the most logical deduction. But it is not the one that has prevailed among critics of theatrical mimesis. They have invariably retained the premises while changing the conclusion. According to them, whoever says 'theatre' says 'spectator' – and therein lies the evil. Such is the circle of theatre as we know it, as our society has shaped it in its image. We therefore need a different theatre, a theatre without spectators: not a theatre played out in front of empty seats, but a theatre where the passive optical relationship implied by the very term is subjected to a different relationship – that implied by another word, one which refers to what is produced on the stage: *drama*. Drama means action. Theatre is the place where an action is taken to its conclusion by bodies in motion in front of living bodies that are to be mobilized. The latter might have relinquished their power. But this power is revived, reactivated in the performance of the former, in the intelligence which constructs that performance, in the energy it generates.

It is on the basis of this active power that a new theatre must be built, or rather a theatre restored to its original virtue, to its true essence, of which the spectacles that take this name offer nothing but a degraded version. What is required is a theatre without spectators, where those in attendance learn from as opposed to being seduced by images; where they become active participants as opposed to passive voyeurs.

There have been two main formulations of this switch, which in principle are conflicting, even if the practice and the theory of a reformed theatre have often combined them. According to the first, the spectator must be roused from the stupefaction of spectators enthralled by appearances and won over by the empathy that makes them identify with the characters on the stage. He will be shown a strange, unusual spectacle, a mystery whose meaning he must seek out. He will thus be compelled to exchange the position of passive spectator for that of scientific investigator or experimenter, who observes phenomena and searches for their causes. Alternatively, he will be offered an exemplary dilemma, similar to those facing human beings engaged in decisions about how to act. In this way, he will be led to hone his own sense of the evaluation of reasons, of their discussion and of the choice that arrives at a decision.

According to the second formulation, it is this reasoning distance that must itself be abolished. The spectator must be removed from the position of observer calmly examining the spectacle offered to her. She must be dispossessed of this illusory mastery, drawn into the magic circle of theatrical action where she will exchange the privilege of rational observer for that of the being in possession of all her vital energies.

Such are the basic attitudes encapsulated in Brecht's epic theatre and Artaud's theatre of cruelty. For one, the spectator

must be allowed some distance; for the other, he must forego any distance. For one, he must refine his gaze, while for the other, he must abdicate the very position of viewer. Modern attempts to reform theatre have constantly oscillated between these two poles of distanced investigation and vital participation, when not combining their principles and their effects. They have claimed to transform theatre on the basis of a diagnosis that led to its abolition. Consequently, it is not surprising that they have revived not simply the provisions of Plato's critique but also the positive formula which it opposed to the evil of theatre. Plato wanted to replace the democratic, ignorant community of theatre with a different community, encapsulated in a different performance of bodies. To it he counter-posed the choreographic community, where no one remains a static spectator, where everyone must move in accordance with the community rhythm fixed by mathematical proportion, even if that requires getting old people reluctant to take part in the community dance drunk.

Reformers of theatre have reformulated Plato's opposition between *choros* and theatre as one between the truth of the theatre and the simulacrum of the spectacle. They have made theatre the place where the passive audience of spectators must be transformed into its opposite: the active body of a community enacting its living principle. The presentational text of the Sommerakademie that welcomed me put it like this: 'theatre remains the only place where the audience confronts itself as a collective.' In the narrow sense, the sentence merely seeks to distinguish the collective audience of the theatre from individual visitors to an exhibition or the mere sum of admissions to a cinema. But it is clear that it means more. It signifies that 'theatre' is an exemplary community form. It involves an idea of community as self-presence, in contrast to the distance

of representation. Since German Romanticism, thinking about theatre has been associated with this idea of the living community. Theatre emerged as a form of aesthetic constitution – sensible constitution – of the community. By that I mean the community as a way of occupying a place and a time, as the body in action as opposed to a mere apparatus of laws; a set of perceptions, gestures and attitudes that precede and pre-form laws and political institutions. More than any other art, theatre has been associated with the Romantic idea of an aesthetic revolution, changing not the mechanics of the state and laws, but the sensible forms of human experience. Hence reform of theatre meant the restoration of its character as assembly or ceremony of the community. Theatre is an assembly in which ordinary people become aware of their situation and discuss their interests, says Brecht following Piscator. It is, claims Artaud, the purifying ritual in which a community is put in possession of its own energies. If theatre thus embodies the living community, as opposed to the illusion of mimesis, it is not surprising that the desire to restore theatre to its essence can draw on the critique of the spectacle.

What in fact is the essence of the spectacle for Guy Debord? It is exteriority. The spectacle is the reign of vision, and vision is exteriority – that is, self-dispossession. The malady of spectating man can be summed up in a brief formula: 'the more he contemplates, the less he lives'.[2] The formula seems to be anti-Platonic. In fact, the theoretical foundations of the critique of the spectacle are borrowed, via Marx, from Feuerbach's critique of religion. The basis of both critiques consists in the Romantic vision of truth as non-separation. But that idea is

2 Guy Debord, *The Society of the Spectacle*, trans. Donald Nicholson-Smith, New York: Zone Books, 1994, 23.

itself dependent on Plato's conception of *mimesis*. The 'contemplation' denounced by Debord is contemplation of the appearance separated from its truth; it is the spectacle of the suffering produced by that separation: 'Separation is the alpha and omega of the spectacle.'[3] What human beings contemplate in the spectacle is the activity they have been robbed of; it is their own essence become alien, turned against them, organizing a collective world whose reality is that dispossession.

Thus, there is no contradiction between the critique of the spectacle and the quest for a theatre restored to its original essence. 'Good' theatre is one that uses its separated reality in order to abolish it. The paradox of the spectator pertains to the curious device that adopts Plato's prohibition of theatre for theatre. Accordingly, it is these principles that should be re-examined today. Or rather, it is the network of presuppositions, the set of equivalences and oppositions, that underpin their possibility: equivalences between theatrical audience and community, gaze and passivity, exteriority and separation, mediation and simulacrum; oppositions between the collective and the individual, the image and living reality, activity and passivity, self-ownership and alienation.

This set of equivalences and oppositions in fact composes a rather intricate dramaturgy of sin and redemption. Theatre accuses itself of rendering spectators passive and thereby betraying its essence as community action. It consequently assigns itself the mission of reversing its effects and expiating its sins by restoring to spectators ownership of their consciousness and their activity. The theatrical stage and performance thus become a vanishing mediation between the evil of spectacle and the virtue of true theatre. They intend to teach their

3 Ibid., p. 20.

spectators ways of ceasing to be spectators and becoming agents of a collective practice. According to the Brechtian paradigm, theatrical mediation makes them conscious of the social situation that gives rise to it and desirous of acting in order to transform it. According to Artaud's logic, it makes them abandon their position as spectators: rather than being placed in front of a spectacle, they are surrounded by the performance, drawn into the circle of action that restores their collective energy. In both cases, theatre is presented as a mediation striving for its own abolition.

This is where the descriptions and statements of intellectual emancipation and proposals for it might come into play and help us reformulate its logic. For this self-vanishing mediation is not something unknown to us. It is the very logic of the pedagogical relationship: the role assigned to the schoolmaster in that relationship is to abolish the distance between his knowledge and the ignorance of the ignoramus. His lessons and the exercises he sets aim gradually to reduce the gulf separating them. Unfortunately, he can only reduce the distance on condition that he constantly re-creates it. To replace ignorance by knowledge, he must always be one step ahead, install a new form of ignorance between the pupil and himself. The reason is simple. In pedagogical logic, the ignoramus is not simply one who does not as yet know what the schoolmaster knows. She is the one who does not know what she does not know or how to know it. For his part, the schoolmaster is not only the one who possesses the knowledge unknown by the ignoramus. He is also the one who knows how to make it an object of knowledge, at what point and in accordance with what protocol. For, in truth, there is no ignoramus who does not already know a mass of things, who has not learnt them by herself, by listening and looking around her, by observation and

repetition, by being mistaken and correcting her errors. But for the schoolmaster such knowledge is merely an *ignoramus's knowledge*, knowledge that cannot be ordered in accordance with the ascent from the simplest to the most complex. The ignoramus advances by comparing what she discovers with what she already knows, in line with random encounters but also according to the arithmetical rule, the democratic rule, that makes ignorance a lesser form of knowledge. She is concerned solely with knowing more, with knowing what she did not yet know. What she lacks, what the pupil will always lack, unless she becomes a schoolmistress herself, is *knowledge of ignorance* – a knowledge of the exact distance separating knowledge from ignorance.

This measurement precisely eludes the arithmetic of ignoramuses. What the schoolmaster knows, what the protocol of knowledge transmission teaches the pupil in the first instance, is that ignorance is not a lesser form of knowledge, but the opposite of knowledge; that knowledge is not a collection of fragments of knowledge, but a position. The exact distance is the distance that no yardstick measures, the distance that is demonstrated solely by the interplay of positions occupied, which is enforced by the interminable practice of the 'step ahead' separating the schoolmaster from the one whom he is supposed to train to join him. It is the metaphor of the radical gulf separating the schoolmaster's manner from the ignoramus's, because it separates two intelligences: one that knows what ignorance consists in and one that does not. It is, in the first instance, the radical difference that ordered, progressive teaching teaches the pupil. The first thing it teaches her is her own inability. In its activity, it thereby constantly confirms its own presupposition: the inequality of intelligence. This endless confirmation is what Jacotot calls stultification.

To this practice of stultification he counter-posed intellectual emancipation. Intellectual emancipation is the verification of the equality of intelligence. This does not signify the equal value of all manifestations of intelligence, but the self-equality of intelligence in all its manifestations. There are not two sorts of intelligence separated by a gulf. The human animal learns everything in the same way as it initially learnt its mother tongue, as it learnt to venture into the forest of things and signs surrounding it, so as to take its place among human beings: by observing and comparing one thing with another, a sign with a fact, a sign with another sign. If an illiterate knows only one prayer by heart, she can compare that knowledge with what she does not yet know: the words of this prayer as written down on paper. She can learn, one sign after the other, the relationship between what she does not know and what she does know. She can do this if, at each step, she observes what is before her, says what she has seen, and verifies what she has said. From this ignoramus, spelling out signs, to the scientist who constructs hypotheses, the same intelligence is always at work – an intelligence that translates signs into other signs and proceeds by comparisons and illustrations in order to communicate its intellectual adventures and understand what another intelligence is endeavouring to communicate to it.

This poetic labour of translation is at the heart of all learning. It is at the heart of the emancipatory practice of the ignorant schoolmaster. What he does not know is stupefying distance, distance transformed into a radical gulf that can only be 'bridged' by an expert. Distance is not an evil to be abolished, but the normal condition of any communication. Human animals are distant animals who communicate through the forest of signs. The distance the ignoramus has to cover is not the gulf between her ignorance and the schoolmaster's

knowledge. It is simply the path from what she already knows to what she does not yet know, but which she can learn just as she has learnt the rest; which she can learn not in order to occupy the position of the scholar, but so as better to practise the art of translating, of putting her experience into words and her words to the test; of translating her intellectual adventures for others and counter-translating the translations of their own adventures which they present to her. The ignorant schoolmaster who can help her along this path is named thus not because he knows nothing, but because he has renounced the 'knowledge of ignorance' and thereby uncoupled his mastery from his knowledge. He does not teach his pupils *his* knowledge, but orders them to venture into the forest of things and signs, to say what they have seen and what they think of what they have seen, to verify it and have it verified. What is unknown to him is the inequality of intelligence. Every distance is a factual distance and each intellectual act is a path traced between a form of ignorance and a form of knowledge, a path that constantly abolishes any fixity and hierarchy of positions with their boundaries.

What is the relationship between this story and the question of the spectator today? We no longer live in the days when playwrights wanted to explain to their audience the truth of social relations and ways of struggling against capitalist domination. But one does not necessarily lose one's presuppositions with one's illusions, or the apparatus of means with the horizon of ends. On the contrary, it might be that the loss of their illusions leads artists to increase the pressure on spectators: perhaps the latter will know what is to be done, as long as the performance draws them out of their passive attitude and transforms them into active participants in a shared world. Such is the first conviction that theatrical reformers share with

stultifying pedagogues: that of the gulf separating two positions. Even if the playwright or director does not know what she wants the spectator to do, she at least knows one thing: she knows that she must *do one thing* – overcome the gulf separating activity from passivity.

But could we not invert the terms of the problem by asking if it is not precisely the desire to abolish the distance that creates it? What makes it possible to pronounce the spectator seated in her place inactive, if not the previously posited radical opposition between the active and the passive? Why identify gaze and passivity, unless on the presupposition that to view means to take pleasure in images and appearances while ignoring the truth behind the image and the reality outside the theatre? Why assimilate listening to passivity, unless through the prejudice that speech is the opposite of action? These oppositions – viewing/knowing, appearance/reality, activity/passivity – are quite different from logical oppositions between clearly defined terms. They specifically define a distribution of the sensible, an *a priori* distribution of the positions and capacities and incapacities attached to these positions. They are embodied allegories of inequality. That is why we can change the value of the terms, transform a 'good' term into a 'bad' one and vice versa, without altering the functioning of the opposition itself. Thus, the spectator is discredited because she does nothing, whereas actors on the stage or workers outside put their bodies in action. But the opposition of seeing and doing returns as soon as we oppose to the blindness of manual workers and empirical practitioners, mired in immediacy and routine, the broad perspective of those who contemplate ideas, predict the future or take a comprehensive view of our world. In the past, property owners who lived off their private income were referred to as *active*

citizens, capable of electing and being elected, while those who worked for a living were *passive* citizens, unworthy of these duties. The terms can change their meaning, and the positions can be reversed, but the main thing is that the structure counter-posing two categories – those who possess a capacity and those who do not – persists.

Emancipation begins when we challenge the opposition between viewing and acting; when we understand that the self-evident facts that structure the relations between saying, seeing and doing themselves belong to the structure of domination and subjection. It begins when we understand that viewing is also an action that confirms or transforms this distribution of positions. The spectator also acts, like the pupil or scholar. She observes, selects, compares, interprets. She links what she sees to a host of other things that she has seen on other stages, in other kinds of place. She composes her own poem with the elements of the poem before her. She participates in the performance by refashioning it in her own way – by drawing back, for example, from the vital energy that it is supposed to transmit in order to make it a pure image and associate this image with a story which she has read or dreamt, experienced or invented. They are thus both distant spectators and active interpreters of the spectacle offered to them.

This is a crucial point: spectators see, feel and understand something in as much as they compose their own poem, as, in their way, do actors or playwrights, directors, dancers or performers. Let us simply observe the mobility of the gaze and expressions of spectators of a traditional Shiite religious drama commemorating the death of Hussein, captured by Abbas Kiarostami's camera (*Looking at Tazieh*). The playwright or director would like the spectators to see this and feel that, understand some particular thing and draw some particular

conclusion. This is the logic of the stultifying pedagogue, the logic of straight, uniform transmission: there is something – a form of knowledge, a capacity, an energy in a body or a mind – on one side, and it must pass to the other side. What the pupil must *learn* is what the schoolmaster must *teach* her. What the spectator *must see* is what the director *makes her see*. What she must feel is the energy he communicates to her. To this identity of cause and effect, which is at the heart of stultifying logic, emancipation counter-poses their dissociation. This is the meaning of the ignorant schoolmaster: from the schoolmaster the pupil learns something that the schoolmaster does not know himself. She learns it as an effect of the mastery that forces her to search and verifies this research. But she does not learn the schoolmaster's knowledge.

It will be said that, for their part, artists do not wish to instruct the spectator. Today, they deny using the stage to dictate a lesson or convey a message. They simply wish to produce a form of consciousness, an intensity of feeling, an energy for action. But they always assume that what will be perceived, felt, understood is what they have put into their dramatic art or performance. They always presuppose an identity between cause and effect. This supposed equality between cause and effect is itself based upon an inegalitarian principle: it is based on the privilege that the schoolmaster grants himself – knowledge of the 'right' distance and ways to abolish it. But this is to confuse two quite different distances. There is the distance between artist and spectator, but there is also the distance inherent in the performance itself, in so far as it subsists, as a spectacle, an autonomous thing, between the idea of the artist and the sensation or comprehension of the spectator. In the logic of emancipation, between the ignorant schoolmaster and the emancipated novice there is always a third thing – a

book or some other piece of writing – alien to both and to which they can refer to verify in common what the pupil has seen, what she says about it and what she thinks of it. The same applies to performance. It is not the transmission of the artist's knowledge or inspiration to the spectator. It is the third thing that is owned by no one, whose meaning is owned by no one, but which subsists between them, excluding any uniform transmission, any identity of cause and effect.

This idea of emancipation is thus clearly opposed to the one on which the politics of theatre and its reform have often relied: emancipation as re-appropriation of a relationship to self lost in a process of separation. It is this idea of separation and its abolition that connects Debord's critique of the spectacle to Feuerbach's critique of religion via the Marxist critique of alienation. In this logic, the mediation of a third term can be nothing but a fatal illusion of autonomy, trapped in the logic of dispossession and its concealment. The separation of stage and auditorium is something to be transcended. The precise aim of the performance is to abolish this exteriority in various ways: by placing the spectators on the stage and the performers in the auditorium; by abolishing the difference between the two; by transferring the performance to other sites; by identifying it with taking possession of the street, the town or life. And this attempt dramatically to change the distribution of places has unquestionably produced many enrichments of theatrical performance. But the redistribution of places is one thing; the requirement that theatre assign itself the goal of assembling a community which ends the separation of the spectacle is quite another. The first involves the invention of new intellectual adventures, the second a new form of allocating bodies to their rightful place, which, in the event, is their place of communion.

For the refusal of mediation, the refusal of the third, is the affirmation of a communitarian essence of theatre as such. The less the playwright knows what he wants the collective of spectators to do, the more he knows that they should, at any rate, act as a collective, transform their aggregation into community. However, it is high time we examine this idea that the theatre is, in and of itself, a community site. Because living bodies onstage address bodies assembled in the same place, it seems that that is enough to make theatre the vehicle for a sense of community, radically different from the situation of individuals seated in front of a television, or film spectators in front of projected shadows. Curiously, generalization of the use of images and every variety of projection in theatrical production seems to alter nothing in this belief. Projected images can be conjoined with living bodies or substituted for them. However, as long as spectators are assembled in the theatrical space, it is as if the living, communitarian essence of theatre were preserved and one could avoid the question: what exactly occurs among theatre spectators that cannot happen elsewhere? What is more interactive, more communitarian, about these spectators than a mass of individuals watching the same television show at the same hour?

This something, I believe, is simply the presupposition that theatre is in and of itself communitarian. This presupposition continues to precede theatrical performances and anticipate its effects. But in a theatre, in front of a performance, just as in a museum, school or street, there are only ever individuals plotting their own paths in the forest of things, acts and signs that confront or surround them. The collective power shared by spectators does not stem from the fact that they are members of a collective body or from some specific form of interactivity. It is the power each of them has to translate what she

perceives in her own way, to link it to the unique intellectual adventure that makes her similar to all the rest in as much as this adventure is not like any other. This shared power of the equality of intelligence links individuals, makes them exchange their intellectual adventures, in so far as it keeps them separate from one another, equally capable of using the power everyone has to plot her own path. What our performances – be they teaching or playing, speaking, writing, making art or looking at it – verify is not our participation in a power embodied in the community. It is the capacity of anonymous people, the capacity that makes everyone equal to everyone else. This capacity is exercised through irreducible distances; it is exercised by an unpredictable interplay of associations and dissociations.

It is in this power of associating and dissociating that the emancipation of the spectator consists – that is to say, the emancipation of each of us as spectator. Being a spectator is not some passive condition that we should transform into activity. It is our normal situation. We also learn and teach, act and know, as spectators who all the time link what we see to what we have seen and said, done and dreamed. There is no more a privileged form than there is a privileged starting point. Everywhere there are starting points, intersections and junctions that enable us to learn something new if we refuse, firstly, radical distance, secondly the distribution of roles, and thirdly the boundaries between territories. We do not have to transform spectators into actors, and ignoramuses into scholars. We have to recognize the knowledge at work in the ignoramus and the activity peculiar to the spectator. Every spectator is already an actor in her story; every actor, every man of action, is the spectator of the same story.

I shall readily illustrate this point at the cost of a little detour via my own political and intellectual experience. I belong to

a generation that found itself pulled between two opposite requirements. According to the first, those who possessed an understanding of the social system had to teach it to those who suffered because of that system so as to arm them for struggle. According to the second, supposed scholars were in fact ignoramuses who knew nothing about what exploitation and rebellion meant and had to educate themselves among the workers whom they treated as ignoramuses. To respond to this dual requirement, I first of all wanted to rediscover the truth of Marxism, so as to arm a new revolutionary movement, and then to learn the meaning of exploitation and rebellion from those who worked and struggled in factories. For me, as for my generation, neither of these endeavours was wholly convincing. This state of affairs led me to search in the history of the working-class movement for the reasons for the ambiguous or failed encounters between workers and the intellectuals who had come to visit them to educate them or be educated by them. I thus had the opportunity to understand that the affair was not something played out between ignorance and knowledge, any more than it was between activity and passivity, individuality and community. One day in May when I consulted the correspondence of two workers in the 1830s, in order to find information on the condition and forms of consciousness of workers at that time, I was surprised to encounter something quite different: the adventures of two other visitors on different May days, 145 years earlier. One of the two workers had just joined the Saint-Simonian community in Ménilmontant and gave his friend the timetable of his days in utopia: work and exercises during the day, games, choirs and tales in the evening. In return, his correspondent recounted the day in the countryside he had just spent with two mates enjoying a springtime Sunday. But what he recounted was nothing like

the day of rest of a worker replenishing his physical and mental strength for the working week to come. It was an incursion into quite a different kind of leisure: the leisure of aesthetes who enjoy the landscape's forms and light and shade, of philosophers who settle into a country inn to develop meta-physical hypotheses there, of apostles who apply themselves to communicating their faith to all the chance companions encountered on the path or in the inn.[4]

These workers, who should have supplied me with informa-tion on working conditions and forms of class consciousness, provided me with something altogether different: a sense of similarity, a demonstration of equality. They too were specta-tors and visitors within their own class. Their activity as propagandists could not be separated from their idleness as strollers and contemplators. The simple chronicle of their leisure dictated reformulation of the established relations between *seeing*, *doing* and *speaking*. By making themselves spectators and visitors, they disrupted the distribution of the sensible which would have it that those who work do not have time to let their steps and gazes roam at random; and that the members of a collective body do not have time to spend on the forms and insignia of individuality. That is what the word 'emancipation' means: the blurring of the boundary between those who act and those who look; between individuals and members of a collective body. What these days brought the two correspondents and their fellows was not knowledge of their condition and energy for the following day's work and the coming struggle. It was a reconfiguration in the here and now of the distribution of space and time, work and leisure.

4 Cf. Gabriel Gauny, *Le Philosophe plébéien*, Paris: Presses Univer-sitaires de Vincennes, 1985, pp. 147–58.

Understanding this break made at the very heart of time was to develop the implications of a similarity and an equality, as opposed to ensuring its mastery in the endless task of reducing the irreducible distance. These two workers were themselves intellectuals, as is anyone and everyone. They were visitors and spectators, like the researcher who a century and a half later read their letters in a library, like the visitors of Marxist theory or the distributors of leaflets at factory gates. There was no gap to be filled between intellectuals and workers, any more than there was between actors and spectators. There followed various conclusions as to the discourse that could account for this experience. Recounting the story of their days and nights made it necessary to blur other boundaries. This story which told of time, its loss and re-appropriation, only assumed meaning and significance by being related to a similar story, told elsewhere, in another time and a quite different genre of writing – in Book 2 of the *Republic* where Plato, before assailing the mendacious shadows of the theatre, explains that in a well-ordered community everyone has to do one thing and that artisans do not have the time to be anywhere other than their workplace and to do anything other than the work appropriate to the (in)capacities allocated them by nature.

To understand the story of these two visitors, it was there-fore necessary to blur the boundaries between empirical history and pure philosophy; the boundaries between disci-plines and the hierarchies between levels of discourse. There was not on the one hand the factual narrative and on the other the philosophical or scientific explanation ascertaining the reason of history or the truth concealed underneath. It was not a case of the facts and their interpretation. There were two different ways of telling a story. And what it came down to me to do was a work of translation, showing how these tales of

springtime Sundays and the philosopher's dialogues translated into one another. It was necessary to invent the idiom appropriate to this translation and counter-translation, even if it meant this idiom remaining unintelligible to all those who requested the meaning of this story, the reality that explained it, and the lesson it contained for action. In fact, this idiom could only be read by those who would translate it on the basis of their own intellectual adventure.

This biographical detour returns me to my central point. These stories of boundaries to cross, and of a distribution of roles to be blurred, in fact coincide with the reality of contemporary art, in which all specific artistic skills tend to leave their particular domain and swap places and powers. Today, we have theatre without speech, and spoken dance; installations and performances by way of plastic works; video projections transformed into series of frescos; photographs treated as *tableaux vivants* or history paintings; sculpture metamorphosed into multimedia shows; and other combinations. Now, there are three ways of understanding and practising this mélange of genres. There is that which relaunches the form of the total artwork. It was supposed to be the apotheosis of art become life. Today, it instead tends to be that of a few outsize artistic egos or a form of consumerist hyper-activism, if not both at once. Next, there is the idea of a hybridization of artistic means appropriate to the postmodern reality of a constant exchange of roles and identities, the real and the virtual, the organic and mechanical and information-technology prostheses. This second idea hardly differs from the first in its consequences. It often leads to a different form of stultification, which uses the blurring of boundaries and the confusion of roles to enhance the effect of the performance without questioning its principles.

There remains a third way that aims not to amplify effects, but to problematize the cause–effect relationship itself and the set of presuppositions that sustain the logic of stultification. Faced with the hyper-theatre that wants to transform representation into presence and passivity into activity, it proposes instead to revoke the privilege of vitality and communitarian power accorded the theatrical stage, so as to restore it to an equal footing with the telling of a story, the reading of a book, or the gaze focused on an image. In sum, it proposes to conceive it as a new scene of equality where heterogeneous performances are translated into one another. For in all these performances what is involved is linking what one knows with what one does not know; being at once a performer deploying her skills and a spectator observing what these skills might produce in a new context among other spectators. Like researchers, artists construct the stages where the manifestation and effect of their skills are exhibited, rendered uncertain in the terms of the new idiom that conveys a new intellectual adventure. The effect of the idiom cannot be anticipated. It requires spectators who play the role of active interpreters, who develop their own translation in order to appropriate the 'story' and make it their own story. An emancipated community is a community of narrators and translators.

I am aware that of all this it might be said: words, yet more words, and nothing but words. I shall not take it as an insult. We have heard so many orators passing off their words as more than words, as formulas for embarking on a new existence; we have seen so many theatrical representations claiming to be not spectacles but community ceremonies; and even today, despite all the 'postmodern' scepticism about the desire to change existence, we see so many installations and spectacles transformed into religious mysteries that it is not necessarily

scandalous to hear it said that words are merely words. To dismiss the fantasies of the word made flesh and the spectator rendered active, to know that words are merely words and spectacles merely spectacles, can help us arrive at a better understanding of how words and images, stories and performances, can change something of the world we live in.

2

The Misadventures of
Critical Thought

I am certainly not the first to challenge the tradition of social and cultural critique my generation grew up in. Many authors have declared that its days are gone. Once we could have fun denouncing the dark, solid reality concealed behind the brilliance of appearances. But today there is allegedly no longer any solid reality to counter-pose to the reign of appearances, nor any dark reverse side to be opposed to the triumph of consumer society. Let me say at the outset: I do not intend to add my voice to this discourse. On the contrary, I would like to show that the concepts and procedures of the critical tradition are by no means obsolete. They still function very well, precisely in the discourse of those who proclaim their extinction. But their current usage witnesses a complete reversal of their orientation and supposed ends. We must therefore take account of the persistence of a model of interpretation and the inversion of its sense, if we wish to engage in a genuine critique of critique.

To this end, I shall examine some contemporary expressions that illustrate the inversion of the modes of description and demonstration peculiar to the critical tradition in the domains of art, politics and theory. For this I shall start from the domain where that tradition is still most persistent – art, in particular those major international exhibitions where the

presentation of artworks is willingly inscribed in the framework of a general reflection on the state of the world. Thus it was that in 2006 the curator of the Seville Biennial, Okwui Enwezor, devoted the event to unmasking, at the hour of globalization, 'those machineries that decimate and erode social, economic, and political networks'.[1] Foremost among these devastating machineries was obviously the American war machine, and visitors entered the exhibition through rooms devoted to the wars in Afghanistan and Iraq. Alongside images of the civil war in Iraq, visitors could see photographs of anti-war demonstrations taken by a German artist based in New York, Josephine Meckseper. One of these captured the attention: in it, in the background we see a group of demonstrators carrying placards, while the foreground is taken up with a dustbin whose contents are overflowing onto the ground. The photo was called simply *Untitled*, which, in this context, seemed to mean: no need for a title – the image itself is sufficiently eloquent on the subject.

We can understand what the image said by relating the tension between the political placards and the dustbin to an artistic form that is particularly representative of the critical tradition in art – collage. The photograph of the demonstration is not a collage in the technical sense of the term, but its effect exploits the elements that account for the artistic and political success of collage and photomontage: the clash on the same surface of heterogeneous, if not conflicting, elements. In the days of surrealism, the procedure served to express the reality of desire and dreams repressed under the prosaic character of bourgeois quotidian reality. Marxism then seized on it to

1 The precise title of the event was 'The Unhomely: Phantom Scenes in Global Society'.

render palpable, through the incongruous encounter of heterogeneous elements, the violence of the class domination concealed beneath the appearances of quotidian ordinariness and democratic peace. This was the principle of Brecht's alienation effect. In the 1970s, it was still that of the photomontages created by a committed American artist, Martha Rosler, in her series entitled 'Bringing the War Home', which affixed to images of happy American domestic interiors images of the Vietnam War. Thus, against the background of a spacious detached house with inflated balloons in a corner, a montage entitled *Balloons* showed us a Vietnamese man carrying in his arms a dead child, killed by American army bullets. The connection between the two images was supposed to produce a dual effect: awareness of the system of domination that connected American domestic happiness to the violence of imperialist war, but also a feeling of guilty complicity in this system. On the one hand, the image said: here is the hidden reality that you do not know how to see; you must become acquainted with it and act in accordance with that knowledge. But it is not obviously the case that knowledge of a situation entails a desire to change it. That is why the image said something else. It said: here is the obvious reality that you do not want to see, because you know that you are responsible for it. The critical procedure thus aimed to have a dual effect: an awareness of the hidden reality and a feeling of guilt about the denied reality.

The photo of the demonstrators and the dustbin brings into play the same elements as those photomontages: distant war and domestic consumption. Josephine Meckseper is not less opposed to the war of George Bush than Martha Rosler was to the war of Richard Nixon. But the interplay of opposites works quite differently. It does not link American over-consumption

to the distant war in order to bolster activist energies hostile to the war. Indeed, it hurls this over-consumption at the feet of the demonstrators who are again claiming to be bringing the war home. Martha Rosler's photomontages accentuated the heterogeneity of the elements: the image of the dead child could not be integrated into the beautiful interior without exploding it. By contrast, the photograph of the demonstrators and the dustbin underscores their basic homogeneity. The cans spilling out of the dustbin have probably been thrown into it by the demonstrators. The photograph thus suggests to us that their march is itself a march of image consumers and spectacular indignations. This way of reading the image is in tune with the installations that have made Josephine Meckseper famous. On view today in many exhibitions, these installations are small showcases, similar to commercial or advertising display cases, in which, as in the photomontages of the past, she assembles elements that are supposed to belong to heterogeneous universes. For example, in an installation entitled *For Sale* we see a book on the history of a group of English urban guerrillas, who precisely wanted to carry the war into the imperialist metropolises, amid male fashion items; in another, a lingerie mannequin alongside a poster of communist propaganda, or the May '68 slogan 'Never Work' on some perfume bottles. These things are seemingly contradictory, but what is involved is showing that they belong to the same reality; that political radicalism is likewise a phenomenon of youth fashion. This is what the photograph of the demonstrators attests to in its way. They are protesting against the war prosecuted by the empire of consumption that releases bombs on Middle Eastern cities. But these bombs are a response to the destruction of the Twin Towers, which had itself been staged as the spectacle of the collapse of the empire of commodities

and the spectacle. Thus, the image seems to say to us: these demonstrators are there because they have consumed images of the collapse of the towers and the bombing in Iraq. And it is yet another spectacle that they are offering us in the streets. In the last instance, terrorism and consumption, protest and spectacle, are reduced to one and the same process governed by the commodity law of equivalence.

But were this visual demonstration to be taken to its logical conclusion, it would lead to the abolition of the critical procedure: if everything is nothing but spectacular exhibition, the contrast between appearance and reality that grounded the effectiveness of the critical discourse disappears, and with it, any guilt about the beings situated on the side of the dark or denied reality. In that case, the critical system would simply reveal its own extinction. Yet that is not how it is. The small display cases that mix revolutionary propaganda and youth fashion follow the dual logic of the activist intervention of the past. They still tell us: here is the reality you do not know how to see – the boundless reign of commodity exhibition and the nihilist horror of today's petty-bourgeois lifestyle. But also: here is the reality you do not want to see – the participation of your supposed gestures of revolt in this process of exhibiting signs of distinction governed by commodity exhibition. Artistic critique therefore always proposes to generate the short-circuit and clash that reveal the secret concealed by the exhibition of images. In Martha Rosler, the clash was intended to reveal the imperialist violence behind the happy display of goods and images. In Josephine Meckseper, the display of images proves to be identical to the structure of a reality where everything is exhibited in the manner of a commodity display. But it is always a question of showing the spectator what she does not know how to see, and making her feel ashamed of what she

does not want to see, even if it means that the critical system presents itself as a luxury commodity pertaining to the very logic it denounces.

There is thus clearly a dialectic inherent in the denunciation of the critical paradigm: it proclaims the obsolescence of the latter only to reproduce its mechanism; to transform the ignorance of reality or the denial of misery into ignorance of the fact that reality and misery have disappeared; to transform the desire to ignore what makes us guilty into the desire to ignore the fact that there is nothing we need feel guilty about. Such, in substance, is the argument defended not by an artist but by a philosopher, Peter Sloterdijk, in his book *Sphären III*. As he describes it, the process of modernity is a process of anti-gravitation. In the first instance, the term obviously refers to the technical inventions that have enabled human beings to conquer space and those which have replaced the solid industrial world by technologies of communication and virtual reality. But it also expresses the idea that life has lost much of its erstwhile gravity, intending by that its load of suffering, harshness and misery, and with it its weight of reality. As a result, the traditional procedures of critical thinking based on 'definitions of reality formulated by the ontology of poverty' no longer have any rationale. If they survive, according to Sloterdijk, it is because belief in the solidity of reality and feelings of guilt about misery survive the loss of their object. They survive it in the mode of necessary illusion. Marx saw human beings as projecting the inverted image of their real misery into the heaven of religion and ideology. According to Sloterdijk, our contemporaries do the opposite: they project into the fiction of a solid reality the inverted image of this process of generalized lightening: 'Whatever the idea expressed in the public space, it is the lie of misery that writes the text. All

discourses are subject to the law that consists in re-translating the luxury that has come to power into the jargon of misery.'[2] The guilty embarrassment experienced at the disappearance of gravity and misery is supposedly expressed upside down by adopting the old discourse of misery and victimization.

This analysis invites us to liberate ourselves from the forms and content of the critical tradition. But it only does so at the price of reproducing its logic. It once again tells us that we are victims of a comprehensive structure of illusion, victims of our ignorance and resistance to an irresistible total process of development of the productive forces: the process of de-materialization of wealth whose consequence is the loss of old beliefs and ideals. It is easy to recognize in this line of argument the indestructible logic of the *Communist Manifesto*. It is not for nothing that a putative postmodernism has had to borrow from it its canonical formula: 'All that is solid melts into air'. Everything supposedly becomes fluid, liquid, gaseous; and it only remains to laugh at ideologues who still believe in the reality of reality, misery and wars.

However provocative in intent, these theses remain trapped in the logic of the critical tradition. They remain faithful to the thesis of the ineluctable historical process and its necessary effect: the mechanism of inversion that transforms reality into illusion or illusion into reality, poverty into wealth or wealth into poverty. They continue to denounce an inability to know and a desire to ignore. And they still point to a culpability at the heart of that denial. This critique of the critical tradition therefore still employs its concepts and procedures. But something, it is true, has changed. Yesterday, these procedures still intended to create forms of consciousness and energies

2 Peter Sloterdijk, *Sphären III. Schäume*, Frankfurt: Suhrkamp, 2004.

directed towards a process of emancipation. Now they are either entirely disconnected from this horizon of emancipation or clearly directed against his dream.

Such is the context illustrated by the fable of the demonstrators and the dustbin. The photograph indeed shows no disapprobation of the demonstrators. After all, in the 1960s Godard was already waxing ironic about the 'children of Marx and Coca-Cola'. However, he marched with them because, when they marched against the Vietnam War, the children of the age of Coca-Cola were fighting, or at any rate thought they were fighting, alongside the children of Marx. What has changed in the past forty years is not that Marx has disappeared, absorbed by Coca-Cola. He has not disappeared. He has changed places. He is now lodged at the heart of the system as its ventriloquist's voice. He has become the infamous spectre or the infamous father who testifies to the shared infamy of the children of Marx and Coca-Cola. Gramsci once characterized the Soviet Revolution as a revolution against *Capital*, against the book by Marx that had become the Bible of bourgeois scientism. We might say the same of the Marxism that my generation grew up in: the Marxism of the denunciation of the mythologies of the commodity, of the illusions of the consumer society, and of the empire of the spectacle. Forty years ago, it was supposed to denounce the machinery of social domination in order to equip those challenging it with new weapons. Today, it has become exactly the opposite: a disenchanted knowledge of the reign of the commodity and the spectacle, of the equivalence between everything and everything else and between everything and its own image. This post-Marxist and post-Situationist wisdom is not content to furnish a phantasmagorical depiction of a humanity completely buried beneath the rubbish of its frenzied consumption. It also

depicts the law of domination as a force seizing on anything that claims to challenge it. It makes any protest a spectacle and any spectacle a commodity. It makes it an expression of futility, but also a demonstration of culpability. The voice of the ventriloquist spectre tells us that we are doubly guilty, guilty for two opposite reasons: because we stick with the old verities of reality and culpability, affecting not to know that there is no longer anything to feel guilty about; but also because, through our own consumption of commodities, spectacles and protests, we contribute to the infamous reign of commodity equivalence. This dual inculpation involves a remarkable redistribution of political positions. On the one hand, the old left-wing denunciation of the empire of commodities and images has become a form of ironic or melancholic acquiescence to this ineluctable empire. On the other, activist energies have turned to the right, where they fuel a new critique of the commodity and the spectacle whose depredations are re-characterized as the crimes of democratic individuals.

Thus, on the one hand we have left-wing irony or melancholy. It urges us to admit that all our desires for subversion still obey the law of the market and that we are simply indulging in the new game available on the global market – that of unbounded experimentation with our own lives. It shows us absorbed into the belly of the beast, where even our capacities for autonomous, subversive practices, and the networks of interaction that we might utilize against it, serve the new power of the beast – that of immaterial production. The beast, so it is said, gets a stranglehold on the desires and capacities of its potential enemies by offering them, at the cheapest price, the most desirable of commodities – the capacity to experiment with one's life as a fertile ground for infinite possibilities. It thus offers everyone what they might desire: reality TV shows

for the cretinous and increased possibilities of self-enhance-
ment for the malign. This, the melancholic discourse tells us,
is the trap into which those who believed in bringing down
capitalist power, and who instead furnished it with the means
to rejuvenate itself by feeding off oppositional energies, have
fallen. This discourse has found its fuel in Luc Boltanski and
Ève Chiapello's *The New Spirit of Capitalism*. According to
these sociologists, the slogans of the revolts of the 1960s, and
especially of the student movement of May '68, supplied
capitalism, which was in difficulty after the oil crisis of 1973,
with the resources to regenerate itself. May '68 supposedly
prioritized the themes of the 'artistic critique' of capitalism –
protest against a disenchanted world and demands for authen-
ticity, creativity and autonomy – as against its 'social' critique,
specific to the working-class movement: the critique of
inequalities and misery and the denunciation of the egotism
that destroys the bonds of community. These are the themes
that have arguably been incorporated by contemporary capi-
talism, supplying those desires for autonomy and authentic
creativity with its newfound 'flexibility', its flexible supervi-
sion, its light, innovative structures, its appeal to individual
initiative and the 'projective city'.

In itself, the thesis is pretty flimsy. There is a world of dif-
ference between the discourses for managerial seminars that
supply it with its material and the reality of contemporary
forms of capitalist domination, where labour 'flexibility' sig-
nifies forced adaptation to increased forms of productivity
under the threat of redundancies, closures and relocations,
rather than an appeal to the generalized creativity of the chil-
dren of May '68. As it happens, concern for creativity at work
was foreign to the slogans of the 1968 movement. Quite the
reverse, it campaigned against the theme of 'participation' and

the invitation to educated, generous youth to participate in a modernized and humanized capitalism that were at the heart of 1960s neo-capitalist ideology and state reformism. The opposition between the artistic critique and the social critique is not based on any analysis of historical forms of protest. In line with Bourdieu's teaching, it makes do with attributing the struggle against misery and for community bonds to workers and the individualist desire for autonomous creativity to the fleetingly rebellious children of the big or petty bourgeoisie. But the collective struggle for working-class emancipation has never been separate from a new experience of individual existence and capacities, wrested from the constraint of old bonds of community. Social emancipation was simultaneously an aesthetic emancipation, a break with the ways of feeling, seeing and saying that characterized working-class identity in the old hierarchical order. This solidarity of the social and the aesthetic, the discovery of individuality for all and the project of free collectivity, was at the heart of working-class emancipation. But by the same token it signified the disordering of classes and identities that the sociological view of the world has always rejected, against which it was itself constructed in the nineteenth century. It is perfectly natural for it to rediscover such disorder in the slogans of 1968, and one understands its anxiety finally to liquidate the disruption they caused to the rightful distribution of classes, their ways of being and forms of action.

It is therefore neither the novelty nor the strength of the thesis that has proved seductive, but the way in which it puts the 'critical' theme of the complicit illusion back to work. It thus provides fuel for the melancholic version of leftism, which feeds off the dual denunciation of the power of the beast and the illusions of those who serve it when they think they

are fighting it. It is true that the thesis of the recuperation of 'artistic' revolts leads to several conclusions: on occasion, it underpins proposals for a radicalism that would at last be radical: the mass defection of the forces of the General Intellect, today absorbed by Capital and the State, advocated by Paolo Virno; or the virtual subversion counter-posed to virtual capitalism by Brian Holmes.[3] It also fuels proposals for an inverted activism, aimed no longer at destroying but at saving a capitalism that has lost its spirit.[4] But its normal pitch is disenchanted registration of the impossibility of changing the ways of a world that lacks any solid point for opposing the reality of domination, which has become gaseous, liquid, immaterial. Indeed, what can the demonstrators/consumers photographed by Josephine Meckseper do when faced with a war which is described as follows by one of the eminent sociologists of our time?

> The prime technique of power is now escape, slippage, elision and avoidance, the effective rejection of any territorial confinement with its cumbersome corollaries of order-building, order-maintenance and the responsibility for the consequences of it all as well as of the necessity to bear the costs ... Blows delivered by stealthy fighter planes and 'smart' self-guided and target-seeking missiles – delivered by surprise, coming from nowhere and immediately

3 See Paolo Virno, *Miracle, virtuosité et 'déjà-vu'. Trois essais sur l'idée de 'monde'*, Paris: Éditions de l'Éclat, 1996; Brian Holmes, 'The Flexible Personality: For a New Cultural Critique', in *Hieroglyphs of the Future: Arts and Politics in a Networked Era*, Paris and Zagreb: Broadcasting Project, 2002 (also available at www.transform.eipcp.net), as well as 'Réveiller les fantômes collectifs. Résistance réticulaire, personnalité flexible' (www.republicart.net).

4 Bernard Stiegler, *Mécréance et discrédit 3. L'esprit perdu du capitalisme*, Paris: Galilée, 2006.

vanishing from sight – replaced the territorial advances of the infantry troops and the effort to dispossess the enemy of its territory ... Military force and its 'hit and run' war-plan prefigured, embodied and portended what was really at stake in the new type of war in the era of liquid modernity: not the conquest of a new territory, but crushing the walls which stopped the flow of new, fluid global powers ...[5]

This diagnosis was published in 2000. It has scarcely been fully confirmed by the military actions of the past eight years. But melancholic prediction does not revolve around verifiable facts. It simply tells us: things are not what they seem to be. This is a proposition that does not run the risk of ever being refuted. Melancholy feeds on its own impotence. It is enough for it to be able to convert it into a generalized impotence and reserve for itself the position of the lucid mind casting a disenchanted eye over a world in which critical interpretation of the system has become an element of the system itself.

Opposite this left-wing melancholy we have seen a new right-wing frenzy developing that reformulates denunciation of the market, the media and the spectacle as a critique of the ravages of the democratic individual. By the term 'democracy', dominant opinion previously understood the convergence between a form of government based on public freedoms and an individual way of life based on the freedom to choose offered by the free market. As long as the Soviet Empire lasted, it counter-posed such democracy to the enemy dubbed totalitarianism. But consensus over the formula identifying democracy with the sum of human rights, free markets and

5 Zygmunt Bauman, *Liquid Modernity*, Cambridge: Polity Press, 2000, pp. 11–12.

individual free choice vanished with the disappearance of its enemy. Since 1989, increasingly enraged intellectual campaigns have denounced the deadly impact of the conjunction between human rights and individual free choice. Sociologists, political philosophers and moralists have taken turns explaining to us that human rights, as Marx had clearly seen, are the rights of the bourgeois egotistical individual, the rights of consumers of any commodity; and that these rights are now impelling those consumers to shatter any impediment to their frenzy and thereby destroy all the traditional forms of authority that used to place a limit on the power of the market: schools, religion and the family. That, they have argued, is the real meaning of the word 'democracy': the law of the individual concerned exclusively with satisfying her desires. Democratic individuals want equality. But the equality they want is that which obtains between the seller and the buyer of a commodity. Consequently, what they want is the triumph of the market in all human relations. And the more enamoured they are of equality, the more passionately they help bring about that triumph. On this basis it was easy to prove that the student movements of the 1960s, and in particular that of May '68 in France, aimed solely at the destruction of forms of traditional authority opposed to the generalized invasion of life by the law of Capital; and that their sole effect has been to transform our societies into free aggregates of disconnected molecules, lacking any affiliation, wholly amenable to the exclusive law of the market.

But this new critique of the commodity went a step further by identifying as the result of the democratic thirst for egalitarian consumption not only the reign of the market but also the terrorist and totalitarian destruction of social and human bonds. In the past, individualism was counter-posed to total-

itarianism. But in this new theorization, totalitarianism becomes the result of the individualistic fanaticism for free choice and boundless consumption. At the moment of the collapse of the Twin Towers, an eminent psychoanalyst, jurist and philosopher, Pierre Legendre, explained in *Le Monde* that the terrorist attack was the return of the Western repressed – punishment for the Western destruction of the symbolic order, encapsulated in homosexual marriage. Two years later, an eminent philosopher and linguist, Jean-Claude Milner, gave a more radical twist to this interpretation in his book *Les Penchants criminels de l'Europe démocratique*. The crime he imputed to democratic Europe was quite simply the extermination of Jews. Democracy, he argued, is the reign of social boundlessness; it is inspired by the desire for the unlimited expansion of this process of boundlessness. Because the Jewish people, by contrast, is the people loyal to the law of filiation and transmission, it represented the only obstacle to this tendency inherent in democracy. That is why the latter needed to eliminate it and was the sole beneficiary of this elimination. And in the riots in the French suburbs in November 2005, the spokesman of the French media intelligentsia, Alain Finkielkraut, perceived the direct consequence of the democratic terrorism of unimpeded consumption:

> These people who destroy schools – what are they actually saying? Their message is not a call for help or a demand for more schools or better schools. It is the desire to liquidate the intermediaries between themselves and the objects of their desires. And what are the objects of their desires – it's simple: money, brands, and sometimes girls … they want it all now, and what they want is the ideal of the consumer society. That's what they see on television.[6]

6 Alain Finkielkraut, interview with *Haaretz*, 18 November 2005.

Since the same author asserted that these youth had been pushed into rioting by Islamist fanatics, in the end the demonstration reduced democracy, consumption, puerility, religious fanaticism and terrorist violence to a single figure. The critique of consumption and the spectacle was ultimately identified with the crudest themes of the clash of civilizations and the war on terror.

I have contrasted this right-wing frenzy of post-critical critique with left-wing melancholy. But they are two sides of the same coin. Both operate the same inversion of the critical model that claimed to reveal the law of the commodity as the ultimate truth of beautiful appearances, in order to arm the combatants in the social struggle. The revelation continues. But it is no longer thought to supply any weapon against the empire it denounces. Left-wing melancholy invites us to recognize that there is no alternative to the power of the beast and to admit that we are satisfied by it. Right-wing frenzy warns us that the more we try to break the power of the beast, the more we contribute to its triumph. But this disconnection between critical procedures and their purpose strips them of any hope of effectiveness. The melancholics and the prophets don the garb of enlightened reason deciphering the symptoms of a malady of civilization. But this enlightened reason emerges bereft of any impact on patients whose illness consists in not knowing themselves to be sick. The interminable critique of the system is finally identified with a demonstration of the reasons why this critique lacks any impact.

Obviously, the impotence of enlightened reason is not fortuitous. It is intrinsic to this variety of post-critical critique. The same prophets who deplore the defeat of Enlightenment reason when faced with the terrorism of 'democratic individualism' focus suspicion on that reason. In the 'terror' they

denounce they perceive the consequence of the free floating of individual atoms, released from the bonds of traditional institutions that held human beings together: family, school, religion, traditional solidarities. Now, this line of argument has a clearly identifiable history. It goes back to the counter-revolutionary analysis of the French Revolution. According to it, the French Revolution had destroyed the fabric of the collective institutions that assembled, educated and protected individuals: religion, monarchy, feudal ties of dependence, corporations and so forth. This was the fruit of the spirit of Enlightenment, which was that of Protestant individualism. As a result, these individuals, released, de-cultured and wanting protection, had become available for both mass terrorism and capitalist exploitation. The current anti-democratic campaign openly adopts this analysis of the link between democracy, market and terror. But if it can reduce the Marxist analysis of bourgeois revolution and commodity fetishism to it, it is because Marxism itself grew in this soil and derived more than one nutrient from it. The Marxist critique of human rights, bourgeois revolution and alienated social relations had in fact developed on the terrain of the post-revolutionary and counter-revolutionary interpretation of the democratic revolution as a bourgeois individualist revolution rending the fabric of community. And it is only natural that the critical reversal of the critical tradition derived from Marxism should lead back to it.

It is therefore false to say that the tradition of social and cultural critique is exhausted. It is doing very well, in the inverted form that now structures the dominant discourse. Quite simply, it has been restored to its original terrain: interpretation of modernity as an individualist sundering of the social bond and of democracy as mass individualism. Therewith it has been

restored to the original tension between the logic of this inter-
pretation of 'democratic modernity' and the logic of social
emancipation. The current disconnection between critique of
the market and the spectacle and any emancipatory aim is the
ultimate form of a tension which, from the start, has haunted
the movement for social emancipation.

To understand this tension, we need to return to the original
meaning of the word 'emancipation': emergence from a state
of minority. This state of minority which the activists of social
emancipation wanted to escape from is, in principle, the same
thing as the 'harmonious fabric of community' that the think-
ers of counter-revolution were dreaming about two centuries
ago, and about which post-Marxist thinkers of the lost social
bond feel misty-eyed today. The harmoniously structured
community that is the subject of their nostalgia is one where
everyone is in their place, their class, taken up with the duty
allocated to them, and equipped with the sensory and intellec-
tual equipment appropriate to that place and duty. It is Plato's
community, where artisans must remain in their place because
work does not wait – it does not allow time for going to chat in
the agora, deliberate at the assembly and watch shadows in the
theatre – but also because the divinity has given them the iron
soul, the sensory and intellectual equipment, that adapts and
fixes them to their occupation. This is what I call the 'police
distribution of the sensible': the existence of a 'harmonious'
relationship between an occupation and an equipment;
between the fact of being in a specific time and place, practis-
ing particular occupations there, and being equipped with the
capacities for feeling, saying and doing appropriate to those
activities. In fact, social emancipation signified breaking this
fit between an 'occupation' and a 'capacity', which entailed an
incapacity to conquer a different space and a different time. It

signified dismantling the labouring body adapted to the occupation of an artisan who knows that work does not wait and whose senses are adapted to this 'absence of time'. Emancipated workers fashioned in the here and now a different body and a different 'soul' for this body – the body and soul of those who are not adapted to any specific occupation; who employ capacities for feeling and speaking, thinking and acting, that do not belong to any particular class, but which belong to anyone and everyone.

But this idea and this practice of emancipation were historically blended with a quite different idea of domination and liberation and, in the end, subjected to it: the one that linked domination with a process of separation and, in consequence, liberation with regaining a lost unity. According to this vision, summed up in exemplary fashion in the texts of the young Marx, subjection to the law of Capital was the law of a society whose unity had been shattered, whose wealth had been alienated, projected above or against it. Emancipation could then only appear as a general re-appropriation of a good lost by the community. And this re-appropriation could only be the result of knowledge of the total process of that separation. From this perspective, the forms of emancipation of those artisans who fashioned a new body to live in a new sensible world here and now could be an illusion, generated by the process of separation and by ignorance of that process. Emancipation could only occur as the end-point of the total process that had separated society from its truth.

On this basis, emancipation was no longer conceived as the construction of new capacities. It was the promise of science to those whose illusory capacities could be nothing but the reverse side of their real incapacity. But the very logic of science was that of an endless deferment of the promise. The

science that promised freedom was also the science of the total process whose effect is endlessly to generate its own ignorance. That is why it constantly had to set about deciphering deceptive images and unmasking the illusory forms of self-enrichment, which could only enclose individuals in the trap of illusion, subjection and misery that bit more. We know the degree of passion attained, between the time of Roland Barthes' *Mythologies* and Guy Debord's *Society of the Spectacle*, by the critical reading of images and the unveiling of the deceptive messages they concealed. We also know how this passion for deciphering the deceptive messages of any image was inverted in the 1980s, with the disabused assertion that there was no longer any room for distinguishing between image and reality. But this inversion is simply the consequence of the original logic that conceives the total social process as a process of self-concealment. In the end, the hidden secret is nothing but the obvious functioning of the machine. That is the truth of the concept of spectacle as fixed by Guy Debord: the spectacle is not the display of images concealing reality. It is the existence of social activity and social wealth as a separate reality. The situation of those who live in the society of the spectacle is thus identical to that of the shackled prisoners in Plato's cave. The cave is the place where images are taken for realities, ignorance for knowledge, and poverty for wealth. And the more the prisoners imagine themselves capable of constructing their individual and collective lives differently, the more they sink into the servitude of the cave. But this declaration of impotence rebounds on the science that proclaims it. To know the law of the spectacle comes down to knowing the way in which it endlessly reproduces the falsification that is identical to its reality. Debord summarized the logic of this circle in a lapidary formula: 'In a

world that *really* has been turned on its head, truth is a moment of falsehood.'[7] Thus, knowledge of the inversion itself belongs to the inverted world, knowledge of subjection to the world of subjection. That is why the critique of the illusion of images could be converted into a critique of the illusion of reality, and the critique of false wealth into a critique of false poverty. The putative postmodern turn is, in this sense, merely another turn in the same circle. There is no theoretical transition from modernist critique to postmodern nihilism. It is simply a question of reading the same equation of reality and the image, wealth and poverty, in a different direction. From the very beginning, the nihilism attributed to the postmodern temperament might well have been the hidden secret of the science that claimed to reveal the hidden secret of modern society. That science fed off the indestructibility of the secret and the endless reproduction of the process of falsification it denounced. The current disconnection between critical procedures and any prospect of emancipation simply reveals the disjunction at the heart of the critical paradigm. It can mock its illusions, but it reproduces its logic.

That is why a genuine 'critique of critique' cannot be a further inversion of its logic. It takes the form of a re-examination of its concepts and its procedures, their genealogy and the way in which they became intertwined with the logic of social emancipation. In particular, it takes the form of a new look at the history of the obsessive image around which inversion of the critical model occurred – the image, totally hackneyed and yet endlessly serviceable, of the poor cretin of an individual consumer, drowned by the flood of commodities and images

7 Guy Debord, *The Society of the Spectacle*, trans. Donald Nicholson-Smith, New York: Zone Books, 1994, p. 14.

and seduced by their false promises. This obsessive concern with the baleful display of commodities and images, and this representation of their blind, self-satisfied victim, did not arise in the age of Barthes, Baudrillard and Debord. They became established in the second half of the nineteenth century, in a very specific context. It was when physiology discovered the multiplicity of nervous stimuli and circuits in place of what had been the unity and simplicity of the soul; and when, with Taine, psychology transformed the brain into a 'polyp of images'. The problem is that this scientific promotion of quantity coincided with another – that of the popular multitude which was the subject of the form of government called democracy; that of the multiplicity of those individuals without qualities whom the proliferation of reproduced texts and images, window displays in shopping precincts and lights in public towns, was transforming into full inhabitants of a shared world of knowledge and pleasures.

It was in this context that a rumour began to be heard: too many stimuli have been unleashed on all sides; too many thoughts and images are invading brains that have not been prepared for mastering this abundance; too many images of possible pleasures are held out to the sight of the poor in big towns; too many new pieces of knowledge are being thrust into the feeble skulls of the children of the common people. This stimulation of their nervous energy is a grave danger. What results is an unleashing of unknown appetites producing, in the short term, new assaults on the social order; in the long run, exhaustion of solid, hardworking stock. Lamentation about a surfeit of consumable commodities and images was first and foremost a depiction of democratic society as one in which there are too many individuals capable of appropriating words, images and forms of lived experience. Such was in fact the

great anxiety of nineteenth-century elites: anxiety about the circulation of these unprecedented forms of lived experience, likely to give any passerby, visitor or reader materials liable to contribute to the reconfiguration of her life-world. This multiplication of unprecedented encounters was also an awakening of original capacities in popular bodies. Emancipation – that is to say, the dismantling of the old distribution of what could be seen, thought and done – fed on this multiplication. Denunciation of the misleading seduction of the 'consumer society' was initially the deed of elites gripped by terror at the twin contemporary figures of popular experimentation with new forms of life: Emma Bovary and the International Workingmen's Association. Obviously, this terror took the form of paternal solicitude for poor people whose fragile brains were incapable of mastering such multiplicity. In other words, the capacity to reinvent lives was transformed into an inability to judge situations.

This paternal concern, and the diagnosis of incapacity it involved, were widely adopted by those who wanted to use the science of social reality to enable the men and women of the people to become aware of their real situation disguised by mendacious images. They endorsed them because they espoused their own vision of the general dynamic of commodity production as automatic production of illusions for the agents subjected to them. In this way, they also endorsed the transformation of capacities dangerous for the social order into fatal incapacities. In effect, the procedures of social critique have as their goal treating the incapable: those who do not know how to see, who do not understand the meaning of what they see, who do not know how to transform acquired knowledge into activist energy. And doctors need these patients to look after. To treat incapacities, they need to reproduce

them indefinitely. Now, to ensure that reproduction, the twist suffices which periodically transforms health into sickness and sickness into health. Forty years ago, critical science made us laugh at the imbeciles who took images for realities and let themselves be seduced by their hidden messages. In the interim, the 'imbeciles' have been educated in the art of recognizing the reality behind appearances and the messages concealed in images. And now, naturally enough, recycled critical science makes us smile at the imbeciles who still think such things as concealed messages in images and a reality distinct from appearances exist. The machine can work in this way until the end of time, capitalizing on the impotence of the critique that unveils the impotence of the imbeciles.

Therefore, I do not want to add another twist to the reversals that forever maintain the same machinery. Instead, I have suggested the need and direction of a change of approach. At the heart of this approach is the attempt to uncouple the link between the emancipatory logic of capacity and the critical logic of collective inveiglement. To escape the circle is to start from different presuppositions, assumptions that are certainly unreasonable from the perspective of our oligarchic societies and the so-called critical logic that is its double. Thus, it would be assumed that the incapable are capable; that there is no hidden secret of the machine that keeps them trapped in their place. It would be assumed that there is no fatal mechanism transforming reality into image; no monstrous beast absorbing all desires and energies into its belly; no lost community to be restored. What there is are simply scenes of dissensus, capable of surfacing in any place and at any time. What 'dissensus' means is an organization of the sensible where there is neither a reality concealed behind appearances nor a single regime of presentation and interpretation of the given imposing its

obviousness on all. It means that every situation can be cracked open from the inside, reconfigured in a different regime of perception and signification. To reconfigure the landscape of what can be seen and what can be thought is to alter the field of the possible and the distribution of capacities and incapacities. Dissensus brings back into play both the obviousness of what can be perceived, thought and done, and the distribution of those who are capable of perceiving, thinking and altering the coordinates of the shared world. This is what a process of political subjectivation consists in: in the action of uncounted capacities that crack open the unity of the given and the obviousness of the visible, in order to sketch a new topography of the possible. Collective understanding of emancipation is not the comprehension of a total process of subjection. It is the collectivization of capacities invested in scenes of dissensus. It is the employment of the capacity of anyone whatsoever, of the quality of human beings without qualities. As I have said, these are unreasonable hypotheses. Yet I believe that today there is more to be sought and found in the investigation of this power than in the endless task of unmasking fetishes or the endless demonstration of the omnipotence of the beast.

3

Aesthetic Separation, Aesthetic Community

By way of introduction, I shall start with a brief analysis of three propositions about community and separation. I shall take the word 'proposition' in its widest sense: a proposition means a statement; it means a proposal or offer; and it also means an artistic operation that lends itself to some form of response or interaction.

The first proposition I shall comment on is the shortest. It is a poetic statement in four words, four French words – 'Séparés, on est ensemble' – which I shall translate as follows: 'Apart, we are together'. This statement is quoted from a prose poem by Mallarmé, 'The White Water Lily'. Let me remind you what the poem is about. The poet makes a short boat trip in order to see a lady who is supposed to be staying somewhere along the river in the neighbourhood. As he approaches the place where he believes her to be, he hears the faint noise of footsteps that might be the sign of the presence of the invisible lady. Having enjoyed that proximity, the poet decides to preserve the mystery of the lady and the secret of their 'being together' inviolate, by silently departing without either seeing her or being seen by her.

The poem was first published in a magazine entitled *Art and Fashion*. So it is easy to attribute the paradox of 'being together apart' to the sophisticated attitude of a poet in search

 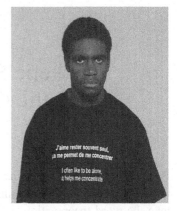

of metaphysical purity and refined sensations. Such a facile
approach is obliged to ignore two things. The first is that the
solitude of being together was displayed at the same time on
two large canvasses that were to become paradigms of modern
painting – namely, Seurat's *Un dimanche après-midi à l'île de
la Grande Jatte* and *Bathers at Asnières*, two pictures alleg-
edly conceived of as modern transpositions of the Athenian
frieze of the Panathenaea. Secondly, the poet himself under-
lined that the crisis of the verse was part of an 'ideal crisis'
which, he said, was itself dependent on a 'social crisis'. This
suggests that the very form of the prose poem may have some
kind of connection with the painterly conjunction of high art
and popular leisure – some kind of relation, I would add, that
might itself be a 'distant' relation, as in the relationship
between the silent boater and the invisible lady.

 Apparently, contemporary art and social life no longer have
anything to do with those poetic landscapes of the 1880s.
Indeed, we live at a time when artists do not much care for
water lilies – except for the purposes of postmodern parody –
or even for painting. We also live in cities where suburban

youths have darker skin and a more boisterous attitude than the teenagers of *Bathers at Asnières*. But it is precisely here that the question of being together when apart assumes a new shape and a new meaning. Many contemporary artists no longer set out to create works of art. Instead, they want to get out of the museum and induce alterations in the space of every-day life, generating new forms of relations. Their propositions thereby engage with the new forms and new discontents of social life around Asnières. This is true of a project proposed by a group of French artists called *Campement Urbain* (Urban Encampment). The project engages with the situation of one of the most wretched outskirts of Paris, where violent riots erupted in the autumn of 2005. Now, the way the project tackles the problem seems paradoxical. Much of what we read or hear about the 'crisis in the suburbs' deals with the destruc-tion of the 'social bond' produced by mass individualism, and the need to re-create it. But the project understands this in a very peculiar way, since it proposes to create a place in that wretched suburb which would be 'extremely useless, fragile and non-productive'.[1] This place was to be discussed with any residents who wanted to get involved in such discussions and placed under the responsibility of the community. But it would be dedicated to a specific end – solitude – meaning that it would be conceived and established as a place that could only be occupied by one person at a time for the purposes of solitary contemplation or meditation. That is why the project was called *I and Us*. So 'being together apart' appears to be more than a form of poetic sophistication. Constructing a place for solitude, an 'aesthetic' place, appears to be a task for commit-ted art. The possibility of being apart appears to be precisely

1 www.evensfoundation.be

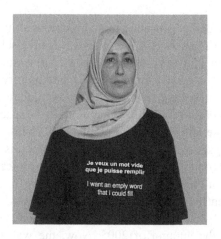

that dimension of social life which is rendered impossible by ordinary life in Parisian suburbs. In a film associated with the project, inhabitants of the neighbourhood were invited to choose a sentence to be printed on a tee-shirt which they would wear in front of the camera (see p.52 and above). This is how a black youth reveals his taste for loneliness. He can be viewed as a descendant of one of the young bathers in Asnières who has met a descendant of the poet: a descendant from the aesthetic point of view – a point of view which is apparently what is required to wrest the issue of community from its ethnic configuration (even if it be a multi-ethnic configuration).

So there is something in common between the prose poem of the refined writer and the contemporary form of political art that tries to create new forms of social bond in 'bad' neighbourhoods. Each of them presents us with one aspect of a common paradox. The 'social crisis' and possible solutions to it are the background to the apparently apolitical poem about the unattainable lady. Conversely, the intervention of a form of art devoted to the construction of empty places seems

required by the underdogs of the poor suburbs. How can we spell out the enigmatic link between those two forms of art? In order to pose the problem, I shall borrow my third 'proposition' from a philosophical work, Deleuze and Guattari's book *What Is Philosophy?* From the section on art I quote a paragraph that is both a definition of what artists do and a statement about the political valency of art:

> The writer twists language, makes it vibrate, seizes hold of it, and rends it in order to wrest the percept from perceptions, the affect from affections, the sensation from opinion – in view, one hopes, of that still-missing people … This is, precisely, the task of all art and, from colours and sounds, both music and painting similarly extract new harmonies, new plastic or melodic landscapes, and new rhythmic characters that raise them to the height of the earth's song and the cry of humanity: that which constitutes tone, health, becoming, a visual and sonorous bloc. A monument does not commemorate or celebrate something that happened but confides to the ear of the future the persistent sensations that embody the event: the constantly renewed suffering of men and women, their re-created protestations, their constantly resumed struggle. Will this all be in vain because suffering is eternal and revolutions do not survive their victory? But the success of a revolution resides only in itself, precisely in the vibrations, clinches, and openings it gave to men and women at the moment of its making and that composes in itself a monument that is always in the process of becoming, like those tumuli to which each new traveller adds a stone.[2]

The philosopher apparently meets our expectations by spelling out what the 'reverie' of the refined poet and the commitment of the contemporary artist have in common: the link between the solitude of the artwork and human community is a matter

2 Gilles Deleuze and Félix Guattari, *What Is Philosophy ?*, trans. by Graham Burchel and Hugh Tomlinson, London: Verso, 1994, p. 76.

of transformed 'sensation'. What the artist does is to weave together a new sensory fabric by wresting percepts and affects from the perceptions and affections that make up the fabric of ordinary experience. Weaving this new fabric means creating a form of common expression or a form of expression of the community – namely, 'the earth's song and the cry of humanity'.

What is common is 'sensation'. Human beings are tied together by a certain sensory fabric, a certain distribution of the sensible, which defines their way of being together; and politics is about the transformation of the sensory fabric of 'being together'. It seems as if the paradox of the 'apart together' has been dispelled. The solitude of the artwork is a false solitude: it is an intertwining or twisting together of sensations, like the cry of a human body. And a human collective is an intertwining and twisting together of sensations in the same way.

But it soon emerges that the sensory transformation of being together undergoes a complex set of connections and disconnections. First, what was traditionally described as a 'modelling' of raw materials becomes a dialectic of 'seizing' and 'rending'. The result of this dialectic is a 'vibration' whose power is transmitted to the human community – that is, to a community of human beings whose activity is itself defined in terms of seizing and rending: suffering, resistance, cries. However, in order for the complex of sensations to communicate its vibration, it has to be solidified in the form of a monument. Now, the monument in turn assumes the identity of a person who speaks to the 'ear of the future'. And that speech itself seems to occur in two forms. The monument transmits the suffering, protest and struggle of human beings. But it does so by transmitting what is apparently opposed to it: the 'earth's song', the song of the inhuman, the song of the

forces of chaos that resist the human desire for transformation. That is how the solitary bloc of sounds and colours can become the 'health' of individuals and communities. Yet such coincidence is problematic. The relationship between the 'bloc' of sounds and colours and the 'health' of the community might only be a matter of analogy. The operations of twisting, seizing and rending that define the way in which art weaves a community together are made *en vue de* – with a view to and in the hope of – a people which is still lacking. The monument is at once the confidant of the people, the instrument of its creation and its representative in its absence. The community of sensation seemed to resolve the paradox of the 'apart together' by equating the 'individual' production of art with the fabric of collective life. But the solid end-product of the activity that 'twists' the materials of sculpture or painting remains somewhere between the *cry* of the suffering and struggling people and the 'earth's song', between a voice of human division and a melody of cosmic – inhuman – harmony. The artistic 'voice of the people' is the voice of a people to come. The people to come is the impossible people which, at one and the same time, would be the divided people of protest and the collective harmony of a people in tune with the very breath of nature, be it a chaotic or a 'chaosmatic' nature.

What my three propositions do is define a specific kind of community: let us call it an aesthetic community in general. An aesthetic community is not a community of aesthetes. It is a community of sense, or a *sensus communis*. A *sensus communis* involves three forms of community. At a first level, a community of sense is simply a certain combination of sense data: forms, words, spaces, rhythms and so on. This also involves a combination of different senses of 'sense'. For instance, the words of the poet are a sensory reality which

suggests another sensory reality (the river, the boat, the invisible lady, etc.), which in turn can be perceived as a metaphor for poetic activity. The inhabitants of the suburb put a sentence printed in white on their black tee-shirts and adopt a certain posture to present it to the camera and so on. This is a first level of 'community'. Now, in my three examples this community assumes a specific shape, which I shall call a 'dissensual figure'. For instance, Mallarmé's words are first used as neutral tools to construct a certain sensorium. They describe to us a motion of the arms directed towards a certain aim: reaching a place which can be visualized in space. But on that sensorium they superimpose another sensorium, one organized around what is specific to their own power – sound and absence. They stage a conflict between two regimes of sense, two sensory worlds. That is what dissensus means. The 'fragile' and 'non-productive' construction suspended above the poor suburb imparts visual manifestation and architectural solidity to that dissensual relationship. And the philosopher provides a conceptual frame for that tension between two sensory worlds. This is the second level.

Now what the philosophical proposition indicates is that the tension between being together and being apart is played out on two levels. The artistic 'proposition' conflates two regimes of sense – a regime of conjunction and a regime of disjunction. The community built by that dissensus itself stands in a twofold relationship to another community, a community between human beings. This is the third level: the assemblage of data and the intertwining of contradictory relations are intended to produce a new sense of community. Mallarmé's poetry aims to provide the democratic community with the 'seal' that cannot be supplied by the counting of votes. Its very distance from social engagement is also a way of preserving, in the absence

of the 'crowd', its capacity for intervention in the 'festivals of the future'. The construction of the solitary place aims at creating new forms of socialization and a new awareness of the capacity of anyone and everyone. But collective discussion of its design already actualizes the form of community that is its goal. Deleuze and Guattari elaborate on that dual relationship. On the one hand, the 'community of sense' woven together by artistic practice is a new set of vibrations of the human community in the present; on the other hand, it is a monument that stands as a mediation or a substitute for a people to come. The paradoxical relationship between the 'apart' and the 'together' is also a paradoxical relationship between the present and the future. The artwork is the people to come and it is a monument to its expectation, a monument to its absence. The artistic 'dissensual community' has a dual body. It is a combination of means for producing an effect out of itself: creating a new community between human beings, a new political people. And it is the anticipated reality of that people. The tension between 'being apart' and 'being together' is bound up with another tension between two statuses of artistic practice: as a means for producing an effect and as the reality of that effect. To the extent that it is a dissensual community, an aesthetic community is a community structured by disconnection.

Understanding exactly what is disconnected and what is at stake in that disconnection is crucial to interpreting what 'aesthetics' and the 'politics of aesthetics' mean. The canonical interpretations of artistic modernity and aesthetics propose three major interpretations of 'being together apart'. There is the modernist view of the autonomy of the work of art, which more or less loosely connects its 'being apart' with the 'being together' of a future community. There is the postmodernist view that makes 'being apart' an aristocratic illusion aimed at

rejecting the real laws of our being together. And there is the
aesthetic of the sublime, which turns the modernist 'being
apart' of the artwork into a radical heterogeneity, attesting
to the human condition of heteronomy forgotten by the mod-
ernist dream of a community of emancipated human beings. I
believe that none of these three interpretations identifies what
aesthetic disconnection means – that is to say, what the aes-
thetic break means.

The aesthetic break has generally been understood as a
break with the regime of representation or the mimetic regime.
But what *mimesis* and representation mean has to be under-
stood. What they mean is a regime of concordance between
sense and sense. As epitomized by the classical stage and clas-
sical doctrine, the theatre was the site of a twofold harmony
between sense and sense. The stage was thought of as a magni-
fying mirror where spectators could see the virtues and vices
of their fellow human beings in fictional form. And that vision
in turn was supposed to prompt specific changes in their
minds: Molière's *Tartuffe* supposedly taught spectators to rec-
ognize hypocrites; Voltaire's *Mahomet* to fight for tolerance
against fanaticism, and so on. Now, that ability to produce the
dual effect of intellectual recognition and appropriate emotion
was itself predicated on a regime of concordance inherent in
representation. The performance of the bodies on the stage
was an exhibition of signs of thoughts and emotions that could
be read without any ambiguity, because they possessed a
grammar which was regarded as the language of nature itself.
This is what *mimesis* means: the concordance between the
complex of sensory signs through which the process of *poiesis*
is displayed and the complex of the forms of perception and
emotion through which it is felt and understood – two pro-
cesses which are united by the single Greek word *aisthesis*. In

the first instance, *mimesis* means correspondence between *poiesis* and *aisthesis*. Because there was a language of natural signs, there was a continuity between the intrinsic consistency – or 'autonomy' – of the play and its capacity to produce ethical effects in the minds of the spectators in the theatre and in their behaviour outside the theatre. The 'being apart' of the stage was enveloped in a continuity between the 'being together' of the signs displayed by the representation, the being together of the community addressed by it, and the universality of human nature. The stage, the audience and the world were comprised in one and the same continuum.

Most of our ideas about the political efficacy of art still cling to that model. We may no longer believe that the exhibition of virtues and vices on the stage can correct human behaviour. But we are still prone to believe that the reproduction in resin of a commercial idol will make us resist the empire of the 'spectacle' or that the photography of some atrocity will mobilize us against injustice. Modern or postmodern as we purport to be, we easily forget that the consistency of this model was called into question as early as the 1750s. In his *Letter to D'Alembert on the Theatre*, Rousseau questioned the supposedly direct line from the performance of the actors on the stage to its effect on the minds of the spectators to their behaviour outside the theatre. He made the point about Molière's *Misanthrope*: does the play urge us to praise the sincerity of Alceste against the hypocrisy of the socialites surrounding him? Or does it prompt us to favour their sense of social life over his intolerance? The question remains unanswerable. Indeed, the problem goes back further: how can the theatre expose hypocrites since what they do is what defines its own essence – namely, exhibiting the signs on human bodies of thoughts and feelings that are not *their own*. There is

a gap at the heart of the mimetic continuity. It was spelled out, twenty-three years after Rousseau's *Letter*, by another hypocrite, Franz Moor in Schiller's *The Robbers*: 'the links of nature are broken'. The statement is not a mere matter of family drama. The two Moor brothers – the hypocrite and the rebel – declare in their words and evince in their behaviour the collapse of the idea of nature that sustained the coincidence between the principle of representation and the principle of its ethical efficacy. What was broken was the continuity between thought and its signs on bodies, and also between the performance of living bodies and its effect on other bodies. 'Aesthetics' above all means that very collapse; in the first instance, it means the rupture of the harmony that enabled correspondence between the texture of the work and its efficacy.

There are two ways of coping with the rupture. The first counter-poses to the undecidable effect of the representational mediation a 'being together' without mediation. Such was the conclusion of Rousseau's *Letter*. The evil consists not only in the content of the representation but in its very structure. It consists in the separation between the stage and the audience, between the performance of the bodies on the stage and the passivity of the spectators in the theatre. What must replace the mimetic mediation is the immediate ethical performance of a collective that knows no separation between performing actors and passive spectators. What Rousseau counter-poses to the play of the hypocrite is the Greek civic festival where the city is present to itself, where it sings and dances its own unity. The model is not new. Plato had already opposed the ethical immediacy of the *choros* to the passivity and lie of the theatre. Nevertheless, it could pass for the modern sense of anti-representation: the theatre turned into the 'cathedral of the future' without any separation between stage and audience;

the living community, expressing in its postures the law of its 'being together'. The culmination of this vision was proposed one year before the First World War in the 'temple' of Hellerau near Dresden, where the choruses of *Orpheus and Eurydice* were performed on the stairs constructed by Adolphe Appia by a choir trained in Émile Jaques-Dalcroze's rhythmic gymnastics. The choir itself was supposed to mix the children of the artistic elite of modernist Europe – who made up the bulk of the audience – and the children of workers from the local factory that bore the name German Workshops for Art in Industry. In this way, the representational mediation was entirely absorbed into the immediate fusion of gymnastics and music, activity and spectatorship, art and industry and so on. It was replaced by the immediate communion of all forms of sense and all senses of sense, from factory work to divine music.

We claim to have taken our distance from such utopias. Our artists have learnt to use this form of hyper-theatre to optimize the spectacle rather than to celebrate the revolutionary identity of art and life. But what remains vivid, both in their practice and in the criticism they experience, is precisely the 'critique of the spectacle' – the idea that art has to provide us with more than a spectacle, more than something devoted to the delight of passive spectators, because it has to work for a society where everybody should be active. The 'critique of the spectacle' often remains the alpha and omega of the 'politics of art'. What this identification dispenses with is any investigation of a third term of efficacy that escapes the dilemma of representational mediation and ethical immediacy. I assume that this 'third term' is aesthetic efficacy itself. 'Aesthetic efficacy' means a paradoxical kind of efficacy that is produced by the very rupturing of any determinate link between cause and effect.

It is precisely this indeterminacy that Kant conceptualized when he defined the beautiful as 'what is represented as an object of universal delight apart from any concept'. That definition has often been equated with the old definition of beauty as harmony and has been counterposed to the break of the sublime, thought of as the formula for the modern rupture with representation. I think that this view ignores the radical break with the representational logic that is entailed in the phrase 'apart from any concept'. It means that there is no longer any correspondence between the concepts of artistic *poiesis* and the forms of aesthetic pleasure, no longer any determinate relationship between *poiesis* and *aisthesis*. Art entails the employment of a set of concepts, while the beautiful possesses no concepts. What is offered to the free play of art is free appearance. This means that free appearance is the product of a disconnected community between two sensoria – the sensorium of artistic fabrication and the sensorium of its enjoyment.

That disconnection can be emblematized by the body of a crippled and beheaded statue, the statue known as the Belvedere Torso, which was selected as the masterpiece of Greek art by Winckelmann in his *History of Ancient Art*, published twenty-six years before Kant's *Critique of Judgement*. Winckelmann's descriptions have been subjected to criticism on two counts. On the one hand, his admiration of the still and noble lines of ancient beauty has been scoffed at as naïve by supporters of a sublime artistic modernity in accordance with a revived Dionysian antiquity. On the other hand, it has been denounced as the first expression of the Romantic dream of a new Greece, thereby leading to the disastrous utopia of the community as a work of art and ultimately to the Soviet labour camps and the Nazi extermination of the Jews. These two

views miss the singularity of the kind of 'Greek perfection' embodied in the Torso and in Winckelmann's description. How are we to understand the fact that the paradigm of supreme beauty is provided by the statue of a crippled divinity which has no face to express any feeling, no arms or legs to command or carry out any action? What intensifies the paradox is Winckelmann's decision to consider the statue as a representation of Hercules, the hero of the Twelve Labours. His Hercules was an idle Hercules, Hercules after his labours, who had nothing more to do or suffer, Hercules devoid of will and feeling. He was taken up exclusively with meditating on his past deeds – meditation for which the statue obviously lacked the head that is the seat of thought and which could be discerned only in the muscles of the torso and the back. But what relationship of analogy can there be between reflecting on an action and the muscles of the abdomen? The folds of the torso expressed the meditation in as much as they expressed nothing, in so far as they were similar to the waves of the sea. The Torso, Winckelmann said, was the masterpiece of Greek art, which also meant the supreme expression of Greek liberty. But the sole expression of that liberty was the wavelike folds of the stone which had no relation whatsoever with liberty and were unable to convey any lesson of courage or freedom.

So the putative paradigm of classical beauty in fact encapsulates the collapse of representational logic, which equated beauty with expressiveness. In that sense, its immediate legacy should be sought not in Canova's neo-classical statues but in Kleist's text on puppet theatre – a text that emphasizes the displacement from one body to another, from the expressiveness of the face, the arms or the legs to the body of the dancer whose soul resides in the elbow or the lumbar vertebrae. Such was the principle of modern dance: setting aside the expressions of the

'living body' in order to free the capacities of other 'bodies' by exploring the disjunctions between the functional body, the expressive body and the indeterminate body. The Torso may have been mutilated for entirely incidental reasons. But what is not incidental, what marks a historical watershed, is the identification between the product of that mutilation and the perfection of art. It is the same inversion that had already been performed by Vico when he discovered the 'true' Homer. Homer, he said, was not a poet in the Aristotelian sense: he was not an inventor of plots, characters, expressions and rhythms. Instead, he was a poet because he had not invented them, because his songs were the expression of a time and a people that were unable to tell history from fiction, words from things, concepts from images, or characters from allegories. He was the voice of an infant people that sang because it could not speak, because it could not use articulate language. The aesthetic regime of art begins with that upheaval in the very idea of perfection; and it is that very upheaval which was conceptualized in Kant's analysis of the beautiful.

It would be easy to trace a line from the mutilated Hercules to the Deleuzian 'body without organs'. Obviously, the Deleuzian monument that speaks to the ears of the future is heir to the Schillerian statue that preserves the potential of the liberty that has disappeared as the political liberty of a people, just as Deleuze's description of Bacon's athletic figures in *The Logic of Sensation* restages the scene of Laocoön. But the Deleuzian dramaturgy of the 'athletic figure' is too indebted to the modernist dramaturgy of the sublime break. It obscures the form of dissensuality that is specific to aesthetic work and 'aesthetic' beauty. The dissensual operation takes the form of a superimposition that transforms a given form or body into a new one. Vico reinvents a new figure of the poet out of

Homer's poems. Winckelmann constructs the model of ideal ancient sculpture by reinventing with his words the shape and meaning of a few Greek statues. The same process of subtraction and addition was conducted by modern choreographers: they first stripped the dancer's expressive body of its traditional mimetic capacities and then reduced it to the immobility of the statue in order to release the potentialities of new, as yet unseen bodies from that immobility. In the same way, Mallarmé's poem appears as the 'divination' of the mute language written on the naked floor by the dancer's feet. And the *metteur-en-scène* in search of the living artwork in the cathedral of the future, Adolphe Appia, wrests the characters of the Wagnerian *Gesamtkunstwerk* out of the visual setting imagined for them by the composer and puts them in a space of geometric modules, where the living bodies look like statues to be moulded by the lightening – which means that it must turn them into shadows.

If the art of the *mise-en-scène* became so important in the aesthetic regime of art, it is because it embodies the whole logic of that regime, the way in which sensory presence and ethical immediacy, opposed to representational mediation, are transformed, thwarted and eventually overturned by the powers of subtraction and disconnection of the statue, the words and the shadows. What characterizes the aesthetic regime of art is not the modernist 'truth to the medium'. Nor is it the Deleuzian 'pure sensation' torn away from the sensory-motor regime of experience. The ontology of the dissensual is actually a fictional ontology, a play of 'aesthetic ideas'. The set of relations that constitutes the work operates *as if* it had a different ontological texture from the sensations that make up everyday experience. But there is neither a sensory difference nor an ontological difference. The aesthetic work takes the

place of – is a substitute for – the work that realizes the law of the medium (according to Greenberg's notion) or the law of pure sensation (according to Deleuze's view). The art of film is in the place of the 'cinegraphic art' dreamt of in the 1920s as the pure writing of motion. And when an artist, namely Godard, sets out to revive the true vocation of cinemato-graphic art, he has to do it by the means of another art. Only the video surface, which actually denies the filmic identity of the shots and the practice of cinematographic montage, can demonstrate the iconic individuality of the shot and the dis-continuity of montage. And only the combination of the mobility of video superimposition, the continuum of the com-mentator's voice, and the sound and musical background functions as the equivalent of the constitution of a 'place in the world', which according to Godard is the operation realized by cinema. Just as Mallarmé's poem is constructed in between the poem designed by the feet of the mute dancer and the inner poem of the silent spectator, Godard's *Histoire(s) du cinéma* are constructed in between two 'cinemas': the corpus of cine-matographic works and the body of a fictional cinema that oversteps the corpus of works produced by that medium and can only be displayed by the means of another medium and another art.

What is true of the 'community of sense' constituting the work itself is even truer of the community that is supposed to result from it. The seal that Mallarmé's poetry wants to give to the community, or the new forms of community that the 'fragile' and 'non-productive place' must re-create, or the phi-losopher's 'people to come', must be regarded as the legacy of the statue which represents the incarnation of the life of the Greek people for Winckelmann's imaginary and the Romantic imaginary, but which for us is nothing but the remains of a life

that has disappeared, separated from that life. The Greece that is embodied in the mutilated Torso rejects both the mimetic efficacy of the representation and the ethical hyper-theatre of the people. Schiller's Juno Ludovisi holds out the promise of a free community because it does not speak or act, because it does nothing, wants nothing and offers no model for imitation. Nor is it an element in a religious or civic ritual. It operates no moral improvement or mobilization of individual or collective bodies. It addresses no specific audience. Instead, it remains in front of the anonymous and indeterminate spectators in the museum, who look at it just as they look at a Florentine painting of the Virgin Mary, a Spanish child beggar, a Dutch peasant wedding or a French still life representing fruit or fish. In the Museum – which refers not only to a specific building but also to a form of apportioning the common space and a specific mode of visibility – all those representations are disconnected from any specific destination, offered to the same 'indifferent' gaze. Aesthetic separation is not the constitution of a private paradise for amateurs or aesthetes. Instead, it implies that there can be no private paradise, that the works are torn away from their original destination, from any specific community, and that there is no longer any boundary separating what belongs to the realm of art from what belongs to the realm of everyday life. This is also why the 'aesthetic education' conceptualized by Schiller after reading Kant's third Critique cannot identify with the happy dream of a community united and civilized by the contemplation of eternal beauty.

The aesthetic effect is in fact a relationship between two 'separations'. The works that entered the realm of aesthetic experience at the time when museums were created had originally been produced for a particular destination: the civic

festivals of antiquity, religious ceremonies, the decorum of monarchic power or aristocratic life. But the aesthetic regime separated them from those functions and destinations. The aesthetic sensorium is the sensorium marked by that loss of destination. What is lost, along with the harmony between *poiesis* and *aisthesis*, is the dependence of artistic productions on a distribution of social places and functions. The previous destination of works corresponded to a certain order of bodies, a certain harmony between the places and functions of a social order and the capacities or incapacities of the bodies located in this or that place, devoted to this or that function. According to this idea of a 'social nature', forms of domination were a matter of sensory inequality. The human beings who were destined to think and rule did not have the same humanity as those who were destined to work, earn a living and reproduce. As Plato had put it, one had to 'believe' that God had put gold in the souls of the rulers and iron in the souls of the artisans. That nature was a matter of 'as if'; it existed in the form of the *as if* and it was necessary to proceed as if it existed. The artisans did not need to be convinced by the story in their innermost being. It was enough that they sensed it and that they used their arms, their eyes and their minds as if it were true. And they did so all the better in so far as this lie about their condition being adapted to their kind of soul corresponded to the reality of their condition. This is the point where the *as if* of the community constructed by aesthetic experience meets the *as if* at play in social emancipation. Social emancipation was an aesthetic matter because it meant the dismemberment of the body animated by that 'belief'. To understand this, let us shift from the marble of the mutilated statue to the 'flesh-and-blood' reality of a dissociation between the work of the arms and the activity of a gaze. I take my example from an issue of a

worker's revolutionary newspaper called *Le Tocsin des travailleurs* (The Workers' Tocsin), published during the French Revolution of 1848. Among reports and statements on the situation, this issue contains an apparently apolitical description of the experience of a joiner who worked as a floor-layer. This is how the joiner wrote his diary in the third person:

> Believing himself at home, he loves the arrangement of a room, so long as he has not finished laying the floor. If the window opens out onto a garden or commands a view of a picturesque horizon, he stops his arms and glides in imagination toward the spacious view to enjoy it better than the [owners] of the neighbouring residences.[3]

This is what the aesthetic rupture produced: the appropriation of the place of work and exploitation as the site of a free gaze. It does not involve an illusion but is a matter of shaping a new body and a new sensorium for oneself. Being a worker meant a certain form of correspondence between a sensory equipment and its destination. It meant a determinate body, a determinate coordination between the gaze and the arms. The divorce between the labouring arms and the distracted gaze introduces the body of a worker into a new configuration of the sensible; it overthrows the 'right' relationship between what a body 'can' do and what it cannot. It is no coincidence that this apparently apolitical description was published in a workers' revolutionary newspaper: the possibility of a 'voice of the workers' was conditional upon disqualification of a certain

3 Gabriel Gauny, 'Le travail à la tâche', *Le Tocsin des travailleurs* (June 1848), in Gabriel Gauny, *Le Philosophe plébéien*, Paris: La Découverte and Presses Universitaires de Vincennes, 1983, p. 91. As cited in Jacques Rancière, *The Nights of Labor*, trans. John Drury, Philadelphia: Temple University Press, 1989, p. 81.

worker's body. It was conditional upon the redistribution of the whole set of relationships between capacities and incapacities that define the 'ethos' of a social body. This is also why the same joiner recommends specific readings to his friends: not novels engaging with social issues, but the stories of those romantic characters – Werther, René, Obermann – who suffered from the misfortune that by definition is denied to the worker: the misfortune of having no occupation, of not being equipped for any specific place in society. What literature does is not provide messages or representations that make workers aware of their condition. Rather, it triggers new passions, which means new forms of balance – or imbalance – between an occupation and the sensory equipment appropriate to it. This politics of literature is not the politics of writers: Goethe, Chateaubriand or Senancour certainly did not want to arouse such passions among labourers. It is a politics inherent in literature as an art of writing that has broken the rules which make definite forms of feeling and expression correspond to specific characters or subject matters.

Aesthetic experience has a political effect to the extent that the loss of destination it presupposes disrupts the way in which bodies fit their functions and destinations. What it produces is not rhetorical persuasion about what must be done. Nor is it the framing of a collective body. It is a multiplication of connections and disconnections that reframe the relation between bodies, the world they live in and the way in which they are 'equipped' to adapt to it. It is a multiplicity of folds and gaps in the fabric of common experience that change the cartography of the perceptible, the thinkable and the feasible. As such, it allows for new modes of political construction of common objects and new possibilities of collective enunciation. However, this political effect occurs under the condition of an original

disjunction, an original effect, which is the suspension of any direct relationship between cause and effect. The aesthetic effect is initially an effect of dis-identification. The aesthetic community is a community of dis-identified persons. As such, it is political because political subjectivation proceeds via a process of dis-identification. An emancipated proletarian is a dis-identified worker. But there is no measure enabling us to calculate the dis-identifying effect. On the one hand, the effect escapes the strategy of the artist; on the other, the artistic strategy completes the process of dis-identification, going beyond the point of political subjectivation towards the 'earth's song' – that is to say, towards the construction of new forms of individuation – Deleuzian haecceities – that cancel any form of political subjectivation. On the one hand, the joiner gains access to the community of dis-identified proletarian subjects by appropriating the 'sorrows' of the idle romantic heroes René and Obermann, even against the will of the writers who had invented these characters. On the other hand, the writer Flaubert castigates the peasant's daughter Emma Bovary, who has appropriated the dreams of Bernardin de Saint-Pierre's Virginie. Not only does he make her die, but to her aesthetic, which wants to put some art in her life, he counter-poses his own aesthetics, the impersonal aesthetics of the earth's song or, as he says, the song of 'inanimate existences, inert things that seem animal, vegetative souls, statues that dream and landscapes that think'.[4] 'I want an empty word that I could fill' is what we read on the tee-shirt of one of the suburban immigrant women taking part in the aforementioned project of the 'empty place' (see p. 54). Both the revolutionary joiner and

4 Gustave Flaubert, *La Tentation de Saint Antoine*, Paris: Les Presses françaises, 1924, p. 418.

the peasant's daughter were looking for such words, which the writers unwillingly offered them and then tried to take away by emptying them out again, transforming these words, making them the impersonal breath of the respiration of the infinite. And the bathing at Asnières, the Sunday stroll at the Grande Jatte, or the gaze at the parade on the boulevards painted by Seurat evinced both the enigmatic potential of popular bodies that gained access to 'leisure' and the neutralization of that potential. In similar fashion, the Deleuzian analogy between the torsions of artistic practice, the cry of human beings and the song of the earth both evinces and neutralizes the same tension between the aesthetic effect of dis-identification and its neutralization. The very same thing that makes the aesthetic 'political' stands in the way of all strategies for 'politicizing art'.

This tension has been concealed for as long as the politics of art has been identified with the paradigm of 'critical art'. Critical art plugs the gap by defining a straightforward relationship between political aims and artistic means: the aim is to create an awareness of political situations leading to political mobilization. The means consist in producing a sensory form of strangeness, a clash of heterogeneous elements provoking a rupture in ways of seeing and, therewith, an examination of the causes of that oddity. The critical strategy thus comes down to including the aesthetic effect of sensory rupture within the continuity of the representative cause–effect schema. When Brecht represented the Nazi leaders as cauliflower sellers and had them discuss their vegetable business in classical verse, the clash of heterogeneous situations and heterogeneous languages was supposed to induce awareness both of the commodity relations concealed behind the hymns to race and nation and of the forms of economic and

political domination concealed behind the dignity of high art. When Martha Rosler intertwined photographs of the Vietnam War with adverts for petty-bourgeois furniture and households, epitomizing American happiness, the photomontage was intended to reveal the reality of the imperialist war behind standardized individual happiness and the empire of the commodity behind wars in defence of the 'free world'. In this way, the aesthetic break was absorbed into representational continuity. But there is no reason why the sensory oddity produced by the clash of heterogeneous elements should bring about an understanding of the state of the world; and no reason either why understanding the state of the world should prompt a decision to change it. There is no straightforward road from the fact of looking at a spectacle to the fact of understanding the state of the world; no direct road from intellectual awareness to political action. What occurs instead is a shift from a given sensible world to another sensible world that defines different capacities and incapacities, different forms of tolerance and intolerance. What occurs are processes of dissociation: a break in a relationship between sense and sense – between what is seen and what is thought, what is thought and what is felt. Such breaks can happen anywhere and at any time. But they cannot be calculated.

The distance between the pretensions of critical art and its real forms of efficacy could persist so long as there were patterns of intelligibility and forms of mobilization strong enough to sustain the artistic procedures that were supposed to produce them. When those patterns or forms are eroded by the undermining of political action, the undecidability of critical procedures is exposed. It happens that artists play on that very undecidability. The struggle against the 'society of the spectacle' and the practice of *détournement* still feature on all

agendas and are supposed to be conducted in standard forms such as parodies of promotional films; reprocessed disco sounds; advertising icons or media stars modelled in wax; Disney animals turned into polymorphous perverts; montages of 'vernacular' photographs showing us standardized petty-bourgeois living rooms, overloaded supermarket trolleys, standardized entertainment or the refuse of consumerist civilization, and so on and so forth. These devices continue to occupy many of our galleries and museums with a rhetoric assuming that they help us discover the power of the commodity, the reign of the spectacle or the pornography of power. Given that nobody is unaware of these things, the mechanism ends up revolving around itself and capitalizing on that undecidability. This is dramatically demonstrated by a piece entitled *Revolution Counter-Revolution* by Charles Ray, presented in exhibitions entitled 'Let's Entertain' in Minneapolis and 'Beyond the Spectacle' in Paris. The work's title is justified from a literal point of view because it is presented as a merry-go-round. However, the mechanism of the merry-go-round is uncoupled from the motion of the horses so that they move in opposite directions. But it also functions as a metaphor, because it evinces the double game of 'critical art' while still capitalizing on it.

When the critical model reaches this point of self-cancellation, different attempts to overcome the aesthetic disconnection emerge. The critical model entailed a specific mediation – the production of awareness – between the 'being apart' of the work and the 'being together' of a new community. From its failure many contemporary activist artists draw the conclusion that no mediation is required; that the work can be the direct presentation of another form of community in which artists are directly fashioning new social bonds. This is the case with a

Cuban artist, René Francisco, whose work was shown at the biennales of Havana and São Paulo. This artist had used a grant from an artistic foundation in order to explore the poor suburbs of Havana. Then he had selected an old woman and decided, with some fellow artists, to refurbish her home. The final work shown in the biennales presented the viewer with a cloth screen printed with the image of the old woman, hung so that she appeared to be looking at the 'real' screen of the monitor, where a video showed the artists working as masons, plumbers or painters. Other works step out of the museum and transform the work into a street demonstration where artistic invention appears as a metaphor for its own 'extra-artistic' outcome. This is what happens with artistic inventions such as Lucy Orta's collective clothes, which are used both as a 'home' and as a form of collective bond, in order to create 'lasting connections between groups and individuals'. The same anticipation of 'being together' is documented 'inside' the museums by works that assume the form of large mosaics or tapestries of paintings or photographs representing a multitude of ordinary people. Such works are among the favourites in many international exhibitions. Let us take, for instance, a 'tapestry' called *The People* and made by the Chinese artist Bai Yiluo out of sixteen hundred ID pictures sewn together. The tapestry intended to evoke 'the delicate threads which unite families and communities'. So the work presents itself as the anticipated reality of what it evokes. Art is supposed to 'unite' people in the same way the artist had sewn together the ID pictures that he had previously taken in a photographer's studio. The photograph also leans towards the status of a sculpture that makes present what it is speaking of. The concept of metaphor, omnipresent in the rhetoric of the curators, tends to conceptualize the anticipated identity between the form of

'being together' offered by the artistic proposition and its embodied reality.

In all these instances, critical mediation is replaced by direct anticipation of 'being together' in 'being apart'. But it is possible to escape both positions by constructing the work as the very tension between the apart and the together. This is true of works that try to explore the tension between the two terms, either by questioning the ways in which the community is tentatively produced or by exploring the potential of community entailed in separation itself. As regards the former, I am thinking of a video work by the Albanian artist Anri Sala. The work, which is entitled *Dammi i colori*, uses the powers of video art to question another form of 'political art', aimed at directly framing a new sense of community. The latter is the initiative of the mayor of Tirana, an artist himself, who decided to have the facades of the buildings in his town repainted in bright colours so as to create a new form of social bond based on a shared aesthetic experience. This post-communist project is highly reminiscent of the dream of the revolutionary artists in the epoch of Malevich, Rodchenko and El Lissitzky: the dream of an art directly involved in producing the forms and buildings of a new life. While the mayor is commenting on his project, the movements of Anri Sala's camera confront the discourse of the 'political artist' both with the shabbiness of the muddy street and with the stream of apparently unconcerned passersby. As the camera closes in, the coloured walls destined to create a new aesthetic community are turned into abstract strips of colour. Thus, several walls appear on a single wall; several modernisms and politics of art are confronted. The video artist uses the resources of 'distant' art to question a politics of art which tries to fuse art and life into one single process.

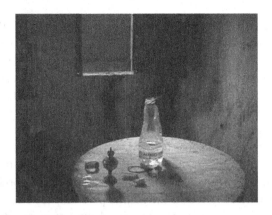

As regards the second way of exploring the tension, I am thinking of the work of the Portuguese filmmaker Pedro Costa, who has devoted three films to the life of a group of young underdogs, hovering between drugs and petty commerce, in a poor suburb of Lisbon. The second film in the trilogy, *In Vanda's Room*, shows them as they are preparing to leave the shantytown that is slowly being torn down by Caterpillar bulldozers. While relational artists are concerned with inventing some real or fancy monument or creating unexpected situations in order to generate new social relationships in the poor suburbs, Pedro Costa paradoxically focuses on the possibilities of life and art specific to that situation of misery: from the strange coloured architectures that result from the degradation of the houses and demolition itself, to the effort made by the inhabitants to recover a voice and the ability to tell their own story amid the effects of drugs and despair. I would like to isolate a short sequence from *In Vanda's Room* showing us three squatters preparing for their move. One of them is scratching the stains on the table with his knife (table pictured above); his friends get nervous and tell him to stop because

they will not be taking the table with them anyway. But he carries on because he cannot stand dirtiness. Perhaps the complicity between the aesthetic sense of the filmmaker, who does not hesitate to exploit all the 'beauty' available in the shantytown, and the aesthetic sense of the poor addict gets closer to the heart of the matter than the mayor of Tirana's project. By setting aside 'explanations' of the economic and social reasons for the existence of the shantytown and its destruction, the film sets forth the specifically political dimension: the confrontation between the power and the impotence of a body, the confrontation between a life and its possibilities. There is no aestheticizing formalism or populist deference in the attention Pedro Costa pays to every beautiful form offered by the homes of the poor, and the patience with which he listens to the often trivial and repetitive words uttered in Vanda's room. The attention and patience are instead inscribed in a different politics of art. This politics does not seek to make viewers aware of the structures of domination and inspire them to mobilize their energies. Nor does it revive the avant-garde's dream of dissolving artistic forms into the relations of a new life. Rather, it finds its model in the music of the Cape Verdean musicians staged in an earlier film by Pedro Costa, *Down to Earth*, or in a love letter which serves as a refrain in his more recent film *Colossal Youth*. The letter talks about a separation and about working on building sites far away from one's beloved. It also speaks about the impending reunion that will grace two lives for twenty or thirty years, about the dream of offering one's beloved a hundred thousand cigarettes, clothes, a car, a little house made of lava, and a threepenny bouquet; it talks about the effort to learn a new word every day – words whose beauty is tailor-made to envelop these two beings like fine silk pyjamas. Pedro Costa composed it by blending letters by Cape

Verdean immigrants and a letter sent by Robert Desnos to his lover from a Nazi camp. It affirms an art in which the form is not split off from the construction of a social relation or from the realization of a capacity that belongs to everyone. The politics of the filmmaker involves using the sensory riches – the power of speech or of vision – that can be extracted from the life and settings of these precarious existences and returning them to their owners, making them available, like a song they can enjoy, like a love letter whose words and sentences they can borrow for their own love lives. After all, is not this what we can expect from the cinema, the popular art of the twentieth century, the art that allowed the greatest number of people to be thrilled by the splendour of the effect of a ray of light shining on an ordinary setting, the poetry of clinking glasses, or a conversation at the counter of a run-of-the-mill café?

But Pedro Costa does not ignore the fact that cinema is no longer what it was once hoped it would be. Contemporary forms of domination frame a world in which equality must disappear even from the organization of the sensible landscape. All the wealth in this landscape has to appear as separated, attributed and privately enjoyed by one category of owners. Neighbourhood cinemas have been replaced by multiplexes that supply each sociologically determinate audience a type of art designed and formatted to suit it. The system gives the humble the small change of its wealth, of its world, which it formats for them, but which is separated from the sensory wealth of their own experience. And Pedro Costa's films, like any work that eludes this formatting process, are immediately labelled film-festival material, something reserved for the exclusive enjoyment of a film-buff elite and tendentiously pushed in the direction of museums and art lovers. The wretched addict of *In Vanda's Room* keeps cleaning a table that was

never his table and that will soon be demolished by the bulldozers. The filmmaker pays homage to his aesthetic sense as he creates a beautiful still life with the objects on the table. He makes a film in the awareness that it is only a film, one which will scarcely be shown and whose effects in the theatres and outside are fairly unpredictable. But it is not only a question of conflict between the politics of the artist and the law of the social system. It is also a question of inner division. The love letter can provide the inspiration for the film along with the idea of art that grounds the practice of the artist, the idea of the sensible world to which it belongs. But the film cannot be the presentation of this sensible world. Cinema cannot be the equivalent of the love letter or music of the poor. It must split itself off; it must agree to be the surface on which an artist tries to cipher in new figures the experience of people relegated to the margins of economic circulation and social trajectories. One art has to be practised in the place of another. And if its political effect stems from its very exteriority to the formatted distribution of thoughts and sensations to formatted audiences, this means that there can be no anticipating that effect. Film, video art, photography, installation and all forms of art can rework the frame of our perceptions and the dynamism of our affects. As such, they can open up new passages towards new forms of political subjectivation. But none of them can avoid the aesthetic cut that separates outcomes from intentions and precludes any direct path towards an 'other side' of words and images.

4

The Intolerable Image

What makes an image intolerable? At first sight, the question seems merely to ask what features make us unable to view an image without experiencing pain or indignation. But a second question immediately emerges, bound up with the first: is it acceptable to make such images and exhibit them to others? We might think of one of the latest provocations by the photographer Oliviero Toscani: the poster showing an anorexic young woman naked and wasting away, put up throughout Italy during Milan Fashion Week in 2007. Some saluted it as a courageous denunciation, exposing the reality of suffering and torture concealed behind the appearances of elegance and luxury. In this exhibition of the truth of the spectacle, others condemned a yet more intolerable form of its reign since, under the guise of indignation, it offered the gaze of viewers not only the beautiful appearance but also the abject reality. To the image of the appearance the photographer counter-posed an image of the reality. But it is the image of the reality that becomes suspect in its turn. What it shows is deemed too real, too intolerably real to be offered in the form of an image. This is not a simple matter of respect for personal dignity. The image is pronounced unsuitable for criticizing reality because it pertains to the same regime of visibility as that reality, which by turns displays its aspect of brilliant appear-

ance and its other side of sordid truth, constituting a single spectacle.

This shift from the intolerable in the image to the intolerability of the image has found itself at the heart of the tensions affecting political art. We know the role played at the time of the Vietnam War by certain photographs, like that of the naked little girl screaming on the road ahead of soldiers. We know how committed artists strove to set the reality of these images of pain and death against advertising images displaying *joie de vivre* in beautiful, well-equipped modern apartments in the country that was sending its soldiers to burn Vietnamese land with napalm. In an earlier chapter, I discussed Martha Rosler's 'Bringing the War Home', particularly the collage that showed us, in the middle of a clear and spacious apartment, a Vietnamese man holding a dead child in his arms. The dead child was the intolerable reality concealed by comfortable American existence; the intolerable reality that it strove not to see and which the montage of political art threw in its face. I stressed how this clash between reality and appearance was cancelled out in contemporary exercises in collage, which make political protest an expression of youth fashion on a par with luxury goods and advertising images. Thus, there would no longer be an intolerable reality which the image could counter-pose to the prestige of appearances, but only a single flood of images, a single regime of universal exhibition; and this regime itself would constitute the intolerable today.

This reversal is not simply caused by the disenchantment of an age that no longer believes either in the means of attesting a reality or in the necessity of fighting injustice. It indicates a duplicity that was already present in the activist employment of the intolerable image. The image of the dead child was supposed to tear apart the image of the artificial happiness of

American existence; it was supposed to open the eyes of those who enjoy this happiness to the intolerability of that reality and to their own complicity, in order to engage them in the struggle. But the generation of this effect remained uncertain. The view of the dead child in the beautiful apartment, with its bright walls and vast proportions, is certainly difficult to tolerate. But there is no particular reason why it should make those who see it conscious of the reality of imperialism and desirous of opposing it. The stock reaction to such images is to close one's eyes or avert one's gaze. Or, indeed, it is to incriminate the horrors of war and the murderous folly of human beings. For the image to produce its political effect, the spectator must already be convinced that what it shows is American imperialism, not the madness of human beings in general. She must also be convinced that she is herself guilty of sharing in the prosperity rooted in imperialist exploitation of the world. And she must further feel guilty about being there and doing nothing; about viewing these images of pain and death, rather than struggling against the powers responsible for it. In short, she must already feel guilty about viewing the image that is to create the feeling of guilt.

Such is the dialectic inherent in the political montage of images. One of them must play the role of the reality that denounces the other's mirage. But by the same token, it denounces the mirage as the reality of our existence in which the image is included. The mere fact of viewing images that denounce the reality of a system already emerges as complicity with this system. At the time when Martha Rosler was constructing her series, Guy Debord was making the film drawn from his book *The Society of the Spectacle*. The spectacle, he said, is the inversion of life. The reality of the spectacle as the inversion of life was shown by his film to be equally embodied in any

image: that of rulers – capitalist or communist – as of cinema stars, fashion models, advertising models, starlets on the beaches of Cannes, or ordinary consumers of commodities and images. All these images were equivalent; they all spoke the same intolerable reality: that of our existence separated from our-selves, transformed by the machine of the spectacle into dead images before us, against us. Thus, it now seemed impossible to confer on any image whatsoever the power of exhibiting the intolerable and prompting us to struggle against it. The only thing to do seemed to be to counter-pose to the passivity of the image, to its alienated existence, living action. But for that, was it not necessary to abolish images, to plunge the screen into darkness so as to summon people to the action that was alone capable of opposing the lie of the spectacle?

In the event, Guy Debord did not install darkness on the screen.[1] On the contrary, he made the screen the theatre of a curious strategic game between three terms: images, action and speech. This singularity clearly emerges in the extracts from westerns and Hollywood war films inserted into *Society of the Spectacle*. When we see John Wayne or Errol Flynn, two Hollywood icons and champions of the American extreme Right, strutting about; when the former recounts his exploits at Shenandoah or the latter charges, sword unsheathed, in the role of General Custer, we are initially tempted to perceive a parodic condemnation of American imperialism and its glori-fication by Hollywood cinema. That is how many understand the *détournement* advocated by Guy Debord. But this is a mis-interpretation. It is in all seriousness that he introduces Errol Flynn's charge, taken from Raoul Walsh's *They Died with*

1 On the other hand, we might recall that he had done so in a previous film, *Hurlements en faveur de Sade*.

Their Boots On, in order to illustrate a thesis about the historical role of the proletariat. He is not asking us to mock these proud Yankees charging with flashing blade and become aware of the complicity of Raoul Walsh or John Ford in imperialist domination. He is asking us to adopt the heroism of the battle for our own purposes; to transform this cinematographic charge, played by actors, into a real assault on the empire of the spectacle. This is the seemingly paradoxical, yet perfectly logical, conclusion of denunciation of the spectacle: if every image simply shows life inverted, rendered passive, it suffices to turn it upside down in order to unleash the active power it has appropriated. This is the lesson offered, more discreetly, by the film's first two images. In them we see two young, beautiful female bodies, jubilant in the light. The hasty spectator risks seeing them as a denunciation of the imaginary possession offered and purloined by the image, something later illustrated by other images of female bodies – strip-tease artists, models, undressed starlets. But this apparent similarity in fact conceals a radical opposition. For these initial images have not been drawn from shows, advertising or newsreels. They have been taken by the artist and represent his companion and a friend. They thus appear as active images, images of bodies involved in active relations of amorous desire, as opposed to being trapped in the passive relationship of the spectacle.

Thus, we need images of action, images of the true reality or images that can immediately be inverted into their true reality, in order to show us that the mere fact of being a spectator, the mere fact of viewing images, is a bad thing. Action is presented as the only answer to the evil of the image and the guilt of the spectator. And yet these are still images being presented to this spectator. This apparent paradox has its rationale: were

she not viewing images, the spectator would not be guilty. But the demonstration of her guilt is perhaps more important to the accuser than is her conversion to action. It is here that the voice which formulates the illusion and guilt assumes its true importance. It denounces the inversion of existence that consists in being a passive consumer of commodities which are images and images which are commodities. It tells us that the only response to this evil is activity. But it also tells us that those of us who are viewing the images it is commenting on will never act, will forever remain spectators of a life spent in the image. The inversion of the inversion thus remains a form of knowledge reserved for those who know why we shall continue not to know, not to act. The virtue of activity, counter-posed to the evil of the image, is thus absorbed by the authority of the sovereign voice that stigmatizes the false existence which it knows us to be condemned to wallow in.

Assertion of the authority of the voice thus emerges as the real content of the critique that took us from what is intolerable in the image to the intolerability of the image. This displacement is what is fully revealed by the critique of the image in the name of the unrepresentable. The paradigmatic example of it was provided by the polemic over the exhibition 'Mémoires des camps', staged a few years ago in Paris. At the centre of the exhibition were four small photographs taken of an Auschwitz gas chamber by a member of the Sonderkommando. These photographs showed a group of naked women being pushed towards the gas chamber and the burning of the corpses in the open air. In the exhibition catalogue, a long essay by Georges Didi-Huberman stressed the weight of reality represented by these 'Four pieces of film snatched from Hell'.[2]

2 The essay is reprinted, together with commentaries and responses

In *Les Temps modernes*, the essay provoked two extremely violent responses. The first, by Élisabeth Pagnoux, used the classical argument: these images were intolerable because they were too real. By projecting into our present the horror of Auschwitz, they captured our gaze and prevented any critical distance. But the second essay, by Gérard Wajcman, inverted the argument: these images, and the commentary accompanying them, were intolerable because they lied. The four photographs did not represent the reality of the Shoah for three reasons: first of all, because they did not show the extermination of the Jews in the gas chamber; next, because reality is never entirely soluble in the visible; and finally, because at the heart of the event of the Shoah there is something unrepresentable – something that cannot structurally be fixed in an image. 'The gas chambers are an event that in itself constitutes a kind of aporia, an unshatterable reality that pierces and problematizes the status of the image and jeopardizes any thinking about images.'[3]

This line of argument would be plausible if it were simply meant to challenge the notion that the four photographs possessed the power to present the totality of the process of the extermination of the Jews, its meaning and resonance. But these photographs, in light of the conditions in which they were taken, obviously do not make this claim; and the argument is in fact directed against something else: it aims to establish a radical opposition between two kinds of representation – the visible image and spoken narrative – and two sorts of attestation – proof and testimony. The four images and the

to criticism, in Georges Didi-Huberman, *Images malgré tout*, Paris: Éditions de Minuit, 2003.

3 Gérard Wajcman, 'De la croyance photographique', *Les Temps modernes*, March–May 2001, p. 63.

commentary are condemned because those who took them, risking their lives, and the person commenting on them regarded them as testimony to the reality of an extermination whose perpetrators did everything they could to erase any trace of it. They are criticized for having believed that the reality of the process was in need of proof and that the visible image afforded such proof. 'However,' retorts the philosopher, 'the Shoah occurred. I know it and everyone knows it. It is a known fact. Every subject is summoned to it. No one can say: "I do not know." This knowledge is based on testimony, which forms a new knowledge … It does not require any proof.'[4] But what precisely is this 'new knowledge'? What distinguishes the virtue of testimony from the indignity of proof? He who testifies in a narrative as to what he has seen in a death camp is engaged in a work of representation, just like the person who sought to record a visible trace of it. His words do not capture the event in its uniqueness either; they are not its horror directly expressed. It will be said that that is their merit: not saying everything; showing that not everything can be said. But this grounds a radical difference from the 'image' only if one arbitrarily attributes to the latter a claim to show everything. The virtue conferred on the speech of the witness is then wholly negative: it consists not in what he says but in its very deficiency, as opposed to the sufficiency attributed to the image, to the deception of this sufficiency. But this is purely a matter of definition. If we stick to the simple definition of the image as duplicate, we can certainly draw from it the straightforward conclusion that this duplicate is opposed to the uniqueness of Reality and thus can only erase the unique horror of the extermination. The image is reassuring, Wajcman

4 Ibid., p. 53.

tells us. The proof is that we view these photographs whereas we would not tolerate the reality they reproduce. The only defect in this argument from authority is that those who saw this reality, and, in the first instance, those who took the images, did indeed have to tolerate it. But this is precisely why the philosopher criticizes the photographer: for having *wanted* to witness. The true witness is one who does not want to witness. That is the reason for the privilege accorded to his speech. But this privilege is not his. It is the privilege of the speech that obliges him to speak despite himself.

This is illustrated by an exemplary sequence in the film that Gérard Wajcman counter-poses to all visual evidence and all archival documents – namely, Claude Lanzmann's *Shoah*, a film based on the testimony of a few survivors. The sequence is the one in the hairdressing salon where the former Treblinka hairdresser Abraham Bomba recounts the arrival and shearing of the men and women who were about to enter the gas chamber. At the heart of the episode is the moment when Bomba, who is referring to the destination of the cut hair, refuses to continue and with his towel wipes away the tears he is beginning to shed. The voice of the director then urges him to continue: 'You must go on, Abe. You have to.' But if he has to, it is not in order to reveal an unknown truth with which those who deny it must be confronted. And in any event, he – he too – will not be saying what happened in the gas chamber. He has to simply because he has to. He has to because he does not want to do it; because he cannot do it. It is not the content of his testimony that matters, but the fact that his words are those of someone whom the intolerability of the event to be recounted deprives of the possibility of speaking; it is the fact that he speaks only because he is obliged to by the voice of another. This voice of the other in the film is that of the

director, but it projects behind it another voice in which the commentator will recognize either the law of the Lacanian symbolic order or the authority of the god who proscribes images, speaks to his people in a cloud and demands to be taken at his word and obeyed absolutely. The speech of the witness is made sacred for three negative reasons: first, because it is the opposite of the image, which is idolatry; next, because it is the speech of a man incapable of speaking; finally, because it is that of a man compelled to speak by a speech more powerful than his own. At the end of the day, the critique of images does not counter-pose to them either the exigencies of action or the restraint of speech. It counter-poses the authority of the voice that alternatively renders one silent and makes one speak.

But here again, the opposition is posited only to be immediately revoked. The force of the silence that translates the unrepresentability of the event exists only through its representation. The power of the voice opposed to images must be expressed in images. The refusal to speak, and the obedience to the voice that commands, must therefore be made visible. When the barber stops his narrative, when he can no longer speak and the voice asks him to go on, what comes into play, what serves as testimony, is the emotion expressed on his face; it is the tears he holds back and those he must wipe away. Wajcman comments on the filmmaker's work as follows: 'in order to summon up gas chambers, he films people and speech, witnesses in the very act of remembering, and over whose face the memories pass as on a cinema screen, in whose eyes we can detect the horror they have seen'.[5] The argument about what is unrepresentable then plays a dual role. On the one

5 Ibid., p. 55.

hand, it opposes the voice of the witness to the lie of the image. But when the voice ceases, it is the image of the suffering face that becomes visible evidence of what the witness's eyes have seen, the visible image of the horror of the extermination. And the commentator who proclaimed it impossible to distinguish in the photograph of Auschwitz between women sent to their death and a group of naturists out walking, seems to experience no difficulty distinguishing between the tearfulness that reflects the horror of the gas chambers and the tearfulness that generally expresses a painful memory for a sensitive soul. The difference, in fact, is not in the content of the image: it simply consists in the fact that the former is voluntary testimony, whereas the second is involuntary. The virtue of the (good) witness consists in the fact that he is the one who simply responds to the double blow of the Reality that horrifies and the speech of the Other which compels.

That is why the irreducible opposition between speech and image can unproblematically become an opposition between two images – one that is intended and one that is not. But the second, obviously, is itself intended by another. It is intended by the filmmaker who never stops asserting that he is first and foremost an artist and that everything we see and hear in his film is the fruit of his art. The dual role of the argument thus teaches us to question, along with the false radicalism of the opposition, the simplistic character of the ideas of representation and image that it is based on. Representation is not the act of producing a visible form, but the act of offering an equivalent – something that speech does just as much as photography. The image is not the duplicate of a thing. It is a complex set of relations between the visible and the invisible, the visible and speech, the said and the unsaid. It is not a mere reproduction of what is out there in front of the photographer

or the filmmaker. It is always an alteration that occurs in a chain of images which alter it in turn. And the voice is not the manifestation of the invisible, opposed to the visible form of the image. It is itself caught up in a process of image construction. It is the voice of a body that transforms one sensible event into another, by striving to make us 'see' what it has seen, to make us see what it tells us. Classical rhetoric and poetics have taught us this: there are images in language as well. They consist in all those figures that replace one expression by another, in order to make us experience the sensible texture of an event better than the 'proper' words would. Similarly, there are figures of rhetoric and poetics in the visible. The tears in the hairdresser's eyes are the sign of his emotion. But this emotion is itself produced by the filmmaker's system and, once he films those tears and links this shot to other shots, they can no longer be regarded as the naked presence of the recollected event. They belong to a process of figuration that is a process of condensation and displacement. They are there in place of words that were themselves in place of the visual representation of the event. They become an artistic figure, an element in a system that aims to furnish a figurative equivalence of what happened in the gas chamber. A figurative equivalence is a system of relations between similarity and dissimilarity, which itself brings into play several kinds of intolerability. The barber's tears link the intolerability of what he saw in the past to the intolerability of what he is asked to say in the present. But we know that more than one critic has deemed intolerable the very system that compels this speech, creates this suffering and offers an image of it to spectators who are likely to view it in the same way they watch the report of a catastrophe on television or episodes of a romantic fiction.

Accusing the accusers is beside the point. On the other hand, what is worthwhile is to rescue the analysis of images from the trial-like atmosphere in which it is still so often immersed. The critique of the spectacle has identified it with Plato's denunciation of the deceptiveness of appearances and the passivity of the spectator. The dogmatists of the unrepresentable have assimilated it to the religious controversy over idolatry. We must challenge these identifications of the use of image with idolatry, ignorance or passivity, if we want to take a fresh look at what images are, what they do and the effects they generate. To that end I would like to examine some works that pose the question of whether images are appropriate to the representation of monstrous events in a different way.

Thus, the Chilean artist Alfredo Jaar has devoted several works to the Rwandan genocide of 1994. None of them displays a single visual document confirming the reality of the massacres. Thus, the installation entitled *Real Pictures* is composed of black boxes. Each of them contains an image of a murdered Tutsi, but the box is closed and the image invisible. The only thing that is visible is the text which describes the box's concealed content. At first sight, therefore, these installations likewise oppose the testimony of words to proof by means of images. But this similarity conceals an essential difference: here the words are detached from any voice; they are themselves taken as visual elements. It is therefore clear that this is not a matter of opposing them to the visible form of the image. It is a question of constructing an image – that is to say, a certain connection between the verbal and the visual. The power of this image is that it disturbs the ordinary regime of that connection, such as it is employed in the official system of information.

To understand it, we must challenge the received opinion that this system drowns us in a flood of images in general, and images of horror in particular, thereby rendering us insensitive to the banalized reality of these horrors. This opinion is widely accepted because it confirms the traditional thesis that the evil of images consists in their very number, their profusion effortlessly invading the spellbound gaze and mushy brain of the multitude of democratic consumers of commodities and images. This view is critical in intent, but it is perfectly in tune with the functioning of the system. For the dominant media by no means drown us in a torrent of images testifying to massacres, massive population transfers and the other horrors that go to make up our planet's present. Quite the reverse, they reduce their number, taking good care to select and order them. They eliminate from them anything that might exceed the simple superfluous illustration of their meaning. What we see above all in the news on our TV screens are the faces of the rulers, experts and journalists who comment on the images, who tell us what they show and what we should make of them. If horror is banalized, it is not because we see too many images of it. We do not see too many suffering bodies on the screen. But we do see too many nameless bodies, too many bodies incapable of returning the gaze that we direct at them, too many bodies that are an object of speech without themselves having a chance to speak. The system of information does not operate through an excess of images, but by selecting the speaking and reasoning beings who are capable of 'deciphering' the flow of information about anonymous multitudes. The politics specific to its images consists in teaching us that not just anyone is capable of seeing and speaking. This is the lesson very prosaically confirmed by those who claim to criticize the televisual flood of images.

The bogus controversy over images thus conceals a matter of counting. This is where the politics of the black boxes assumes its meaning. These boxes, closed but covered with words, give a name and a personal history to those whose massacre was tolerated not out of a surfeit or a lack of images, but because it involved nameless beings without an individual history. Words take the place of photographs because the latter would still be photographs of anonymous victims of mass violence, still in tune with what banalizes massacres and victims. The problem is not counter-posing words to visible images. It is overturning the dominant logic that makes the visual the lot of multitudes and the verbal the privilege of a few. The words do not replace the images. They are images – that is to say, forms of redistribution of the elements of representation. They are figures that substitute one image for another, words for visual forms or visual forms for words. At the same time, these figures redistribute the relations between the single and the multiple, small numbers and large numbers. That is how they are political, if politics in the first instance consists in the changing of places and the counting of bodies. In this sense, the political figure par excellence is metonymy, which gives the effect for the cause or the part for the whole. And it is precisely a politics of metonymy that is employed by another installation by Alfredo Jaar devoted to the Rwandan massacre, *The Eyes of Gutete Emerita* (see p. 98). This is organized around a single photograph showing the eyes of a woman who has seen the massacre of her family: hence effect for cause, but also two eyes for a million massacred bodies. However, for all that they have seen, these eyes do not tell us what Gutete Emerita thinks and feels. They are the eyes of someone endowed with the same power as those who view them, but also with the same power that her brothers and sisters have

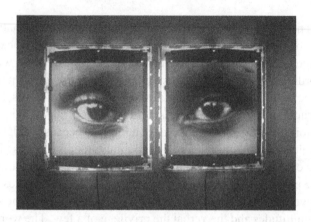

been deprived of by the murderers – that of speaking or remaining silent, of showing one's feelings or hiding them. The metonymy that puts this woman's gaze in place of the spectacle of horror thus disrupts the counting of the individual and the multiple. That is why, before seeing Gutete Emerita's eyes in a luminous box, the spectator has first of all to read a text that shares the same context and recounts the history of these eyes – the history of this woman and her family.

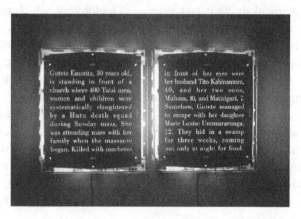

Gutete Emerita, 30 years old, is standing in front of a church where 400 Tutsi men, women and children were systematically slaughtered by a Hutu death squad during Sunday mass. She was attending mass with her family when the massacre began. Killed with machetes in front of her eyes were her husband Tito Kahinamura, 40, and her two sons, Muhoza, 10, and Matirigari, 7. Somehow, Gutete managed to escape with her daughter Marie Louise Unumararunga, 12. They hid in a swamp for three weeks, coming out only at night for food.

The issue of intolerability must then be displaced. The issue is not whether it is necessary to show the horrors suffered by the victims of some particular violence. It revolves around the construction of the victim as an element in a certain distribution of the visible. An image never stands alone. It belongs to a system of visibility that governs the status of the bodies represented and the kind of attention they merit. The issue is knowing the kind of attention prompted by some particular system. Another of Alfredo Jaar's installations can illustrate this point – one he created to reconstruct the space–time of visibility of a single image, a photograph taken in Sudan by the South African photographer Kevin Carter. The photo shows a starving little girl crawling on the ground on the brink of exhaustion, while a vulture perches behind her, awaiting his prey. The fate of the image and of the photographer illustrates the ambiguity of the dominant regime of information. The photograph earned the Pulitzer Prize for the man who had gone into the Sudanese desert and brought back such an arresting image, so apt to shatter the wall of indifference that separates the Western spectator from these distant famines. It also earned him a campaign of indignation: was it not the act of a human vulture to have waited for the moment to take the most spectacular photograph, as opposed to helping the child? Unable to bear this campaign, Kevin Carter killed himself.

Against the duplicity of the system that simultaneously solicits and declines such images, Alfredo Jaar constructed a different system of visibility in his installation *The Sound of Silence*. He set the words and silence of the party involved in order to inscribe the intolerability of the image of the little girl in a wider history of intolerance. If Kevin Carter came to a halt that day, his gaze enthralled by the aesthetic intensity of a monstrous spectacle, it is because he had previously been not

simply a spectator but an actor engaged in the struggle against apartheid in his country. It was therefore appropriate to make the temporality in which this exceptional moment was inscribed felt. But to feel it, the spectator herself had to enter into a specific space–time – a closed booth which she could only enter at the start of an eight-minute projection and only leave at the end of it. What she saw on the screen were more words, words combining to form a kind of poetic ballad recounting the life of Kevin Carter: his experience of apartheid and black uprisings in South Africa; his journey into deepest Sudan up to the moment of the encounter; and the campaign that had pushed him to suicide. It is only towards the end of the ballad that the photograph itself appeared, in a flash of time equivalent to that of the shutter which had taken it. It appeared as something that could not be forgotten, but which it was not necessary to linger over, confirming that the problem is not whether it is necessary to create and view such images, but the sensible system within which it is done.[6]

A different strategy is implemented in a film devoted to the Cambodian genocide, *S-21: The Khmer Rouge Killing Machine*. Its director, Rithy Panh, shares at least two keys things with Claude Lanzmann. He too chose to represent the machine rather than its victims and to make a film in the present. But he dissociated these options from any controversy over word and image. And he did not oppose witnesses to archives. That would unquestionably have been to miss the specificity of a killing machine whose functioning operated

6 I have analyzed some of the works referred to here in greater detail in my essay 'Le Théâtre des images', published in the catalogue *Alfredo Jaar. La politique des images*, Zurich and Musée Cantonal des Beaux-Arts de Lausanne: JRP/Ringier, 2007.

through a highly programmed discursive apparatus and filing system. It was therefore necessary to treat these archives as part of the system, but also to make visible the physical reality of the machine for putting discourse into action and making bodies speak. Rithy Panh therefore brought together two kinds of witnesses on site: some of the very rare survivors of camp S-21 and some former guards. And he made them react to various sorts of archive: daily reports, minutes of interrogations, photographs of dead and tortured prisoners, paintings made from memory by a former prisoner who asks former gaolers to confirm their accuracy. Thus is the logic of the machine reactivated: as the former guards go through these documents, they rediscover the attitudes, the gestures and even the intonations that were theirs when they contributed to the work of torture and death. In a hallucinatory sequence, one of them begins to relive the evening round: the return of prisoners after 'interrogation' into the communal jail; the chains that shackled these prisoners; the broth or cesspit they begged for; the finger pointed at them through the bars; the shouts, insults and threats directed at any prisoner who moved – in short, everything that was part of the guard's daily routine at the time. Seemingly without any qualms, this reconstruction is unquestionably an intolerable spectacle, as if yesterday's torturer were ready to adopt the same role tomorrow. But the whole strategy of the film is to redistribute the intolerable, to play on its various representations: reports, photographs, paintings, reconstructions. It is to shift positions by demoting those who have just expressed their power as torturers once again to the position of school pupils educated by their former victims. The film links various kinds of words, spoken and written, various forms of the visual – cinematographic, photographic, pictorial, theatrical – and several forms of temporality, in order to furnish us

with a representation of the machine that shows us both how it could operate and how it is possible for the executioners and the victims to see it, think about it and feel about it today.

The treatment of the intolerable is thus a matter of *dispositif* of visibility. What is called an image is an element in a system that creates a certain sense of reality, a certain common sense. A 'common sense' is, in the first instance, a community of sensible data: things whose visibility is supposed to be share-able by all, modes of perception of these things, and the equally shareable meanings that are conferred on them. Next, it is the form of being together that binds individuals or groups on the basis of this initial community between words and things. The system of information is a 'common sense' of this kind: a spatiotemporal system in which words and visible forms are assembled into shared data, shared ways of perceiving, being affected and imparting meaning. The point is not to counter-pose reality to its appearances. It is to construct different realities, different forms of common sense – that is to say, different spatiotemporal systems, different communities of words and things, forms and meanings.

This creation is the work of fiction, which consists not in telling stories but in establishing new relations between words and visible forms, speech and writing, a here and an else-where, a then and a now. In this sense, *The Sound of Silence* is a fiction and *Shoah* and *S-21* are fictions. The problem is not whether the reality of these genocides can be put into images and fiction. It is how it is and what kind of common sense is woven by some particular fiction, by the construction of some particular image. It is knowing what kind of human beings the image shows us and what kind of human beings it is addressed to; what kind of gaze and consideration are created by this fiction.

This displacement in relation to the image is also a displacement in the idea of a politics of images. The classic use of the intolerable image traced a straight line from the intolerable spectacle to awareness of the reality it was expressing; and from that to the desire to act in order to change it. But this link between representation, knowledge and action was sheer presupposition. The intolerable image in fact derived its power from the obviousness of theoretical scenarios making it possible to identify its content and from the strength of political movements that translated them into practice. The undermining of these scenarios and movements has resulted in a divorce, opposing the anaesthetizing power of the image to the capacity to understand and the decision to act. The critique of the spectacle and the discourse of the unrepresentable then arrived to fill the stage, fuelling a general suspicion about the political capacity of any image. The current scepticism is the result of a surfeit of faith. It was generated by the disappointed belief in a straight line between perception, affection, comprehension and action. Renewed confidence in the political capacity of images assumes a critique of this strategic schema. The images of art do not supply weapons for battles. They help sketch new configurations of what can be seen, what can be said and what can be thought and, consequently, a new landscape of the possible. But they do so on condition that their meaning or effect is not anticipated.

This resistance to anticipation can be seen illustrated by a photograph taken by the French artist Sophie Ristelhueber (see p. 104). In this picture, a pile of stones is harmoniously integrated into an idyllic landscape of hills covered with olive trees, a landscape similar to that photographed by Victor Bérard to display the permanence of the Mediterranean of Ulysses' voyages. But this little pile of stones in a pastoral

landscape takes on meaning in the set it belongs to. Like all the photographs in the series 'WB' (West Bank), it represents an Israeli roadblock on a Palestinian road. Sophie Ristelhueber has in fact refused to photograph the great separation wall that embodies the policy of a state and is the media icon of the 'Middle Eastern problem'. Instead, she has pointed her lens at these small roadblocks which the Israelis have built on the country roads with whatever means available. And she has invariably done so from a bird's-eye view, from a viewpoint that transforms the blocks of the barriers into elements of the landscape. She has photographed not the emblem of the war, but the wounds and scars it imprints on a territory. In this way, she perhaps effects a displacement of the exhausted affect of indignation to a more discreet affect, an affect of indeterminate effect – curiosity, the desire to see closer up. I speak here of curiosity, and above I spoke of attention. These are in fact affects that blur the false obviousness of strategic schemata;

they are dispositions of the body and the mind where the eye does not know in advance what it sees and thought does not know what it should make of it. Their tension also points towards a different politics of the sensible – a politics based on the variation of distance, the resistance of the visible and the uncertainty of effects. Images change our gaze and the landscape of the possible if they are not anticipated by their meaning and do not anticipate their effects. Such might be the suspensive conclusion of this brief inquiry into the intolerable in images.

5

The Pensive Image

The expression 'pensive image' does not speak for itself. It refers to individuals who are sometimes described as pensive. The adjective describes a curious condition: someone who is pensive is 'full of thoughts', but this does not mean that she is thinking them. In pensiveness, the act of thinking seems to be encroached upon by a certain passivity. Things become complicated when we say of an image that it is pensive. An image is not supposed to think. It contains unthought thought, a thought that cannot be attributed to the intention of the person who produces it and which has an effect on the person who views it without her linking it to a determinate object. Pensiveness thus refers to a condition that is indeterminately between the active and the passive. This indeterminacy problematizes the gap that I have tried to signal elsewhere between two ideas of the image: the common notion of the image as duplicate of a thing and the image conceived as artistic operation. To speak of the pensive image is to signal the existence of a zone of indeterminacy between these two types of image. It is to speak of a zone of indeterminacy between thought and non-thought, activity and passivity, but also between art and non-art.

To analyze the concrete articulation between these opposites, I shall start with some images produced by a practice that is paradigmatically ambivalent as between art and non-art, activity and passivity – namely, photography. The curious fate

of photography vis-à-vis art is well known. In the 1850s, aesthetes like Baudelaire regarded it as a deadly threat: mechanical, vulgar reproduction threatened to supplant the power of the creative imagination and artistic invention. In the 1930s, Benjamin reversed the operation. He made the arts of mechanical reproduction – photography and cinema – the basis for disrupting the very paradigm of art. For Benjamin, the mechanical image broke with the artistic and religious cult of the unique. It was the image that existed solely in and through its relations either with other images or with texts. Thus for him, the photographs taken by August Sander of German social types were elements of a vast social physiognomy that could respond to a practical political problem: the need to recognize friends and enemies in the class struggle. Likewise, the photos of Parisian streets taken by Eugène Atget were stripped of any aura; they appeared divested of the self-sufficiency of 'cultural' artworks. By the same token, they presented themselves as elements of a mystery to be deciphered. They required captions – that is to say, a text explaining the consciousness of the state of the world they expressed. For Benjamin, these photos were 'standard evidence for historical occurrences'.[1] They were the ingredients of a new political art of montage.

Thus were opposed two major ways of thinking about the relationship between art, photography and reality. In the event, this relationship was negotiated in a way that does not correspond to either of these views. On the one hand, our museums and exhibitions increasingly tend to refute both Baudelaire and

1 Walter Benjamin, 'The Work of Art in the Age of Mechanical Reproduction', in *Illuminations*, ed. Hannah Arendt and trans. Harry Zohn, London: Fontana, 1982, p. 228.

Benjamin, by allotting the place of painting to a photography that assumes the format of the painting and imitates its mode of presence. This is true of the series in which the photographer Rineke Dijkstra represents individuals whose identity is uncertain: soldiers captured just before and just after recruitment; amateur bullfighters or slightly gauche adolescents, like the Polish girl (see above) photographed on a beach with her swaying posture and old-fashioned swimming costume – ordinary individuals, inexpressive, but thereby endowed with a certain distance, a certain mystery, similar to that of the portraits which fill museums; portraits of characters who were once representative but who for us have become anonymous. These modes of exhibition tend to make photography the vehicle of a renewed identification between the image as artistic operation and the image as production of a representation. However, at the same time, various new theoretical discourses

denied this identification. On the contrary, they signalled a new form of opposition between photography and art. They made photographic 'reproduction' the singular, irreplaceable emanation of a thing, even if that meant refusing it the status of art. Photography then came to embody an idea of the image as a unique reality resisting art and thought. And the pensiveness of the image became identified with a power of affecting that thwarted the calculations of thought and art.

This view was given exemplary formulation in Roland Barthes's in *Camera Lucida*, where he counterposed the force of pensiveness of the *punctum* to the informative aspect represented by the *studium*. But for that he had to reduce the photographic act and the viewing of the photograph to a single process. Thus, he makes photography into transport: transport of the unique sensible quality of the thing or the being photographed to the viewing subject. To define the photographic act and effect in this way, he has to do three things: set aside the photographer's intention, reduce the technical apparatus to a chemical process and identify the optical relationship with a tactile relationship. Thus is defined a certain view of the photographic affect: according to Barthes, the subject who views must repudiate all knowledge, all reference to that which in the image is an object of knowledge, in order to allow the affect of transport to be generated. To play the image against art is, then, not only to negate the character of the image as object of fabrication; it is almost to negate its character as something seen. Barthes refers to unleashing a mania of the gaze. But this mania of the gaze is in fact its dispossession, its subjection to a process of 'tactile' transport of the sensible quality of the subject photographed.

The opposition between *punctum* and *studium* is clearly made in Barthes' discourse. But it becomes blurred in what

should confirm it: the materiality of the images with which Barthes endeavours to illustrate it. The argument constructed with these examples is, in fact, surprising. Faced with a photograph of two retarded children taken by Lewis Hine in a New Jersey institution (see p. 112), Barthes claims to dismiss any knowledge, any culture. He therefore decides to ignore the inscription of this photograph in the work of a photographer investigating the exploited and rejected of American society. But that is not all. In order to validate his distinction, Barthes must also operate a strange division at the very heart of what links the visual structure of this photograph to its subject – namely, disproportion. Barthes writes: 'I ... hardly see the monstrous heads and pathetic profiles (which belong to the *studium*); what I see ... is the off-centre detail, the little boy's huge Danton collar, the girl's finger bandage ...'[2] But what he tells us he sees by way of the *punctum* pertains to the same logic as that of the *studium*, which he tells us not to see: features of disproportion – an enormous collar in the case of the midget boy; and, in the case of the little girl with a huge head, a bandage which is so tiny that readers of the book would not make it out in the reproduction by themselves. If Barthes has drawn attention to that neck and that bandage, it is clearly for their quality as details – that is to say, as detachable elements. He has chosen them because they correspond to a highly determinate notion: the Lacanian notion of the part object. But here it is not a question of any old part object. It is difficult for us, viewing it in profile, to decide whether the little boy's collar is what shirt-makers call a Danton collar. On the other hand, there is no doubt that the name Danton is that of someone who

2 Roland Barthes, *Camera Lucida: Reflections on Photography*, trans. Richard Howard, London: Jonathan Cape, 1982, p. 51.

was decapitated. The *punctum* of the image is in fact the death evoked by the proper noun Danton. The theory of the *punctum* intends to affirm the resistant singularity of the image. But it ultimately ends up surrendering this specificity by identifying the production and effect of the photographic image with the way in which death or dead people affect us.

This short-circuit is even more evident in another of Barthes's examples: the photograph of a young man in hand-cuffs (see p. 114). Here too the distribution of *studium* and *punctum* is disconcerting. Barthes tells us this: 'The photo-graph is handsome, as is the boy: that is the *studium*. But the *punctum* is: *He is going to die*. I read at the same time: *This will be* and *this has been ...*'[3] Yet nothing in the photo tells us that the young man is going to die. To be affected by his death, we need to know that the photograph represents Lewis Payne, condemned to death in 1865 for trying to assassinate the US secretary of state. And we also need to know that it was the first time a photographer – Alexander Gardner – had been allowed in to photograph an execution. To make the effect of the photo and the affect of death coincide, Barthes has had to create a short-circuit between historical knowledge of the subject represented and the material texture of the photograph.

3 Ibid., p. 96.

These brown colours are those of a photograph from the past, a photograph whose author and subject can be guaranteed to be dead in 1980. Barthes thus reduces the photograph to the Latin *imago*, the effigy that ensured the presence of the dead person, the presence of the ancestor among the living. He thereby reignites a very old controversy over the image. In the first century of our era, in Rome, Pliny the Elder lost his temper with collectors who filled their galleries with statues when they did not know whom they represented – statues that were there for their art, for their beautiful appearance, and not as *images* of ancestors. His position was characteristic of what I call the ethical regime of images. In that regime, a portrait or statue is always an image of someone and derives its legitimacy from its relationship with the human being or god it represents. What Barthes counter-poses to the representative logic of the *studium* is this ancient imagistic function. In a sense, it is this function of effigy, ensuring the permanence of the sensible presence of an individual. However, he is writing in a world and a century where not only artworks but images in general are appreciated for their own sake, not as the souls of ancestors. He must therefore transform the effigy of the ancestor into a *punctum* of death – that is to say, into an affect produced directly on us by the body of the one who faced the lens, who is no longer there, and whose fixing in the image signifies death's grip on the living.

Barthes thus produces a short-circuit between the past of the image and the image of death. Yet this short-circuit erases the characteristic features of the photograph he presents to us, which are features of indeterminacy. The photograph of Lewis Payne in fact derives its singularity from three forms of indeterminacy. The first involves its visual composition: the young man is seated in accordance with a highly pictorial arrangement,

leaning slightly, on the border between a zone of light and a zone of shade. But we cannot know whether the positioning has been chosen by the photographer, or – if that is the case – whether he chose it out of a concern for visibility or an aesthetic reflex. Nor do we know whether he has simply recorded the wedges and marks that appear on the walls, or whether he has deliberately highlighted them. The second indeterminacy concerns the work of time. The texture of the photograph bears the stamp of times past. By contrast, the body of the young man, his clothing, his posture and the intensity of his gaze are at home in our present, negating the temporal distance. The third indeterminacy concerns the attitude of the character. Even if we know that he is going to die and why, it is impossible for us to read the reasons for his assassination attempt, or his feelings about his imminent death, in his gaze. The photograph's pensiveness might then be defined as this tangle between several forms of indeterminacy. It might be characterized as an effect of the circulation, between the subject, the

photographer and us, of the intentional and the unintentional, the known and the unknown, the expressed and unexpressed, the present and the past. Contrary to what Barthes tells us, this pensiveness stems from the impossibility of making two images coincide – the socially determined image of the condemned man and the image of a young man characterized by a rather nonchalant curiosity, focusing on a point we cannot see.

The pensiveness of photography would then be the tension between several modes of representation. The photograph of Lewis Payne presents us with three images, or rather three image functions, in a single image: there is the characterization of an identity; there is the intentional plastic arrangement of a body in a space; and there are those aspects which the mechanical imprint shows us, without us knowing whether they were deliberate. The photograph of Lewis Payne is not an instance of art, but it enables us to understand other photographs that are either intentionally works of art or which simultaneously present a social characterization and an aesthetic indeterminacy. If we return to Rineke Dijkstra's adolescent, we understand why she is representative of the place of photography in contemporary art. On the one hand, she belongs to a series that represents beings of the same kind: adolescents who rather fluctuate in their bodies, individuals who represent identities in transition – between ages, social statuses and lifestyles. Many of these images were taken in former communist countries. On the one hand, then, these photographs characterize ways of being; they testify to the problems of identity that affect individuals belonging to social groups and age groups that are in transition. On the other hand, however, they impose on us raw presences, beings of whom we do not know either what made them decide to pose for an artist or what they intended to show and express in front of the lens. Faced with

them, we are therefore in the same position as when confronted with paintings from the past that represent Florentine or Venetian nobles: we no longer know who they are or what thoughts informed the gaze captured by the painter. To similarity in accordance with the rules of the *studium*, Barthes counter-posed what I have called an archi-similarity, an immediate presence and affect of the body. But what we read in the image of the Polish adolescent is neither of these. It is what I shall call a dis-appropriate similarity. It does not refer us to any real being with which we could compare the image. But nor is it the presence of the unique being spoken of by Barthes. It is that of the ordinary being, whose identity is unimportant, and who hides her thoughts in offering up her face.

One might be tempted to say that this type of aesthetic effect is specific to the portrait, which according to Benjamin is the last refuge of 'religious value'. On the other hand, he tells us, when the human being is absent, photography's expository value definitely prevails. But the distinction between the religious and the expository that structures Benjamin's analysis is arguably as problematic as that between Barthes' *studium* and *punctum*. Let us, for example, look at a photograph taken at the time Benjamin was writing, by a photographer who (like him) numbered Atget and Sander among his favourite references – namely, Walker Evans. It is a photograph of a section of a wooden kitchen wall in Alabama (see p. 118). We know that this photograph forms part of a social venture that Walker Evans at one stage collaborated in – the major investigation into the living conditions of poor farmers commissioned in the late 1930s by the Farm Security Administration – and, more specifically, of a book done in collaboration with James Agee, *Let Us Now Praise Famous Men*. It now belongs to a body of photographs that is viewed in museums as the autonomous

work of an artist. But when we view the photograph, we observe that this tension between art and social reportage stems not simply from the work of time, which transforms documentary evidence about society into artworks. The tension is already at the heart of the image. On the one hand, this section of wall in planks, with its small boards nailed askew and its tinplate cutlery and utensils supported by cross-beams, clearly represents the miserable domestic decor of Alabama farmers. But in order to display such misery, did the photographer really need to take this close-up photo of four boards and a dozen items of cutlery? The elements descriptive of misery at the same time form a certain artistic setting. The rectilinear boards remind us of the quasi-abstract decor presented in the same period by the photographs of Charles Sheeler or Edward Weston, which had no particular social aim. The simplicity of the small nailed board where the cutlery is stored evokes, in its own way, the ideology of modernist architects and designers, in love with simple raw materials and solutions for rational storage, making it possible to expel the horror of bourgeois sideboards. And the arrangement of the askew objects seems to correspond to an aesthetic of the asymmetrical. However, it is impossible for us to know whether all these 'aesthetic' elements are accidents of a poor existence or derive from the taste of the occupants.[4] It is likewise impossible for us to know whether the camera has simply recorded

4 James Agee, who engages in brilliant analyses of the presence or absence of aesthetic concerns in poor people's housing, refers us here to the naked evidence of the photograph: 'In the opposite side of the kitchen is a small bare table from which they eat; and on the walls, what you may see in one of the photographs' (James Agee and Walker Evans, *Let Us Now Praise Famous Men*, London: Peter Owen, 1965, p. 192).

them in passing or whether the photographer has consciously framed and highlighted them; whether he has seen this setting as the index of a lifestyle or as a unique, quasi-abstract combination of lines and objects.

We do not know precisely what Walker Evans had in mind when he took this photograph. But its pensiveness cannot be reduced to our ignorance. For we also know that Walker Evans had a precise idea of photography and art, which, significantly, he derived not from a visual artist, but from a novelist whom he admired: Flaubert. This idea is that the artist must be invisible in his work, just as God is in nature. Walker Evans's viewpoint on the peculiar aesthetic arrangement of domestic objects in a poor Alabama kitchen might in fact remind us of the one Flaubert attributes to Charles Bovary when, on the chipped walls of old Rouault's farm, he comes across the head of Minerva drawn by Emma as a schoolgirl for her father. But above all, in the photographic image of the Alabama kitchen, as in the literary description of the Normandy kitchen, there is the same relationship between the subject's aesthetic quality and art's labour of impersonalization. We should not be misled by the phrase 'aesthetic quality'. It is not a question of sublimating a banal subject via the work of style or framing.

What both Flaubert and Evans do is not an artistic addition to the banal. On the contrary, it is a deletion: what the banal acquires in them is a certain indifference. The neutrality of the sentence or the framing causes the proprieties of social identification to waver. It thus derives from art's effort to make itself invisible. The work of the image captures social banality in the impersonality of art; it removes what makes it the mere expression of a determinate situation or character.

In order to understand the 'pensiveness' at stake in this relationship between the banal and the impersonal, it is worth taking a further step back on the path that led us from Rineke Dijkstra's adolescent to Walker Evans's kitchen, and from Walker Evans's kitchen to Flaubert's. It takes us to those paintings of beggar boys in Seville done by Murillo and kept in Munich's Alte Pinakothek. I stop at them on account of a curious commentary on them by Hegel in his *Lectures on Aesthetics*. He refers to them in passing during a discussion of Flemish and Dutch genre painting, in which he endeavours to overturn the classical evaluation of genres of painting in accordance with the dignity of their subjects. But Hegel does not simply tell us that all subjects are equally appropriate to painting. He establishes a close relationship between the virtue of Murillo's paintings and the activity specific to these beggar boys – an activity that precisely consists in doing nothing, in not caring about anything. In them, he tells us, there is a complete freedom from concern about external things, an inner freedom in external things which is exactly what is claimed by the concept of the artistic ideal. They attest to a beauty that is almost similar to that of the gods on Olympus.[5]

5 *Hegel's Aesthetics: Lectures on Fine Art*, trans. T. M. Knox, Oxford: Clarendon Press, 1998, p. 170.

To offer such a commentary, Hegel must already take it as self-evident that the essential virtue of gods is that they do nothing, care about nothing and want nothing. And he must regard it as obvious that the supreme beauty is the one which expresses this indifference. These beliefs are not self-evidently true. Or rather, they are only self-evidently true in accordance with a break that has already been made in the economy of expressiveness, as in thinking about art and the divine. The 'Olympian' beauty Hegel attributes to the beggar boys is the beauty of the Apollo Belvedere celebrated sixty years earlier by Winckelmann, the beauty of unconcerned divinity. The pensive image is the image of a suspension of activity, which Winckelmann illustrated in his analysis of the Belvedere Torso. For him, this torso was Hercules resting, Hercules serenely thinking about his past exploits, but whose thought was itself wholly expressed in the folds of the back and the stomach whose muscles rippled like rising and falling waves. Activity has become thought, but the thought itself has passed into an immobile motion, similar to the radical indifference of the sea's waves.

What is disclosed in the serenity of the Torso or the little beggars, what confers its pictorial virtue on the photograph of the Alabama kitchen or of the Polish adolescent, is a change of status in the relations between thought, art, action and image. This change marks the transition from a representative regime of expression to an aesthetic regime. Representative logic conferred on the image the status of expressive complement. The thought of the work, be it verbal or visual, was realized in it in the form of 'story' – that is to say, the composition of an action. The image was intended to intensify the power of this action. This intensification took two major forms: on the one hand, features of direct expression, translating into the

expression of faces and the attitude of bodies, the thoughts and feelings that inspired characters and determined their actions; on the other, poetic figures that put one expression in the place of another. In this tradition, the image was therefore two things: the direct representation of a thought or a feeling; and the poetic figure that substitutes one expression for another in order to enhance its power. But the figure could play this role because a relationship of convenience existed between the 'literal' term and the 'figured' term – for example, between an eagle and majesty or a lion and courage. Direct presentation and figural displacement were thus unified in the same regime of similarity. This is the homogeneity between different similarities that specifically defines classical mimesis.

It is with respect to this homogeneous regime that what I have called a dis-appropriate similarity assumes its significance. The modern aesthetic break is often described as the transition from the regime of representation to a regime of presence or presentation. This view has given rise to two major visions of artistic modernity. There is the happy model of the autonomy of art, where the artistic idea is translated into material forms, by short-circuiting the mediation of the image. And there is the tragic model of the 'sublime', where by contrast sensible presence manifests the absence of any commensurable relationship between idea and sensible materiality. Now, our examples make it possible to conceive a third way of thinking about the aesthetic break: it is not the abolition of the image in direct presence, but its emancipation from the unifying logic of action; it is not a rupture in the relationship between the intelligible and the sensible, but a new status of the figure. In its classical sense, the figure combined two meanings: it was a sensible presence and it was an operation of displacement that put one expression in place of another. In the

aesthetic regime, however, the figure is no longer simply an expression that takes the place of another. These are two regimes of expression that find themselves intertwined without having a clearly defined relationship. This is what is emblematized by Winckelmann's description: the thought is in the muscles, which are like stone waves; but there is no relation of expression between the thought and the motion of the waves. The thought has passed into something that does not resemble it by any clear analogy. And the directed activity of the muscles has passed into its opposite: the endless, passive repetition of the motion.

It is now possible to think the pensiveness of the image positively. It is not the aura or *punctum* of the unique apparition. But nor is it simply our ignorance of the author's thought or the resistance of the image to our interpretation. The pensiveness of the image is the result of this new status of the figure that conjoins two regimes of expression, without homogenizing them. To understand it, let us return to literature, which was the first to make this function of pensiveness explicit. In *S/Z*, Roland Barthes commented on the last sentence of Balzac's *Sarrasine*: 'The marquise remained pensive.' The adjective 'pensive' legitimately held his attention: it seemed to refer to a state of mind on the part of the character. However, as placed by Balzac, it actually does something quite different. It effects a displacement of the status of the text. We are in fact at the end of a narrative: the secret of the story has been revealed and this revelation has terminated the narrator's hopes concerning the marquise. Yet at the very point when the narrative comes to an end, 'pensiveness' arrives to deny this end; it arrives to suspend narrative logic in favour of an indeterminate expressive logic. Barthes regarded this 'pensiveness' as the stamp of the 'classical text', a way in which this text signified

that it always had meaning in reserve, a surplus of plenitude. I believe that we can conduct a completely different analysis and, contrary to Barthes, regard such 'pensiveness' as a sign of the modern text – that is to say, of the aesthetic regime of expression. Pensiveness in fact arrives to thwart the logic of the action. On the one hand, it extends the action that had come to a halt. But on the other hand, it puts every conclusion in suspense. What is interrupted is the relationship between narration and expression. The story is frozen in a painting. But this painting signals an inversion in the function of the image. The logic of visuality no longer arrives to supplement action. It arrives to suspend it or rather to duplicate it.

This is what another novelist, Flaubert, can help us to understand. Each of the amorous moments that punctuates *Madame Bovary* is in fact marked by a painting, a small visual scene: a drop of melted snow that falls on Emma's umbrella, an insect on a water-lily leaf, drops of water in the sun, a coach's cloud of dust. It is these paintings, these passive, fleeting impressions, that trigger amorous events. It is as if painting has taken the place of the text's narrative sequence. These painting are no mere setting for the love scene; nor do they symbolize feelings of love: there is no analogy between an insect on a leaf and the genesis of a love. Consequently, neither are they complements of expressiveness lent to the narration. Instead, what we have is an exchange of roles between description and narration, painting and literature. The process of impersonalization can be formulated here as the invasion of literary action by pictorial passivity. In Deleuzian terms, we might speak of a heterogenesis. The visual prompted by the sentence is no longer a complement of expressiveness. Nor is it a simple suspension like the pensiveness of Balzac's marquise. It is an element in the construction of another

narrative chain: a sequence of sensible micro-events that duplicates the classic sequence of causes and effects, of projected ends, their achievement and their consequences. The novel is then constructed as the relationship without relationship between two chains of events: the chain of the narrative directed from the beginning towards the end, with intrigue and dénouement; and the chain of micro-events that does not obey this directed logic, but which is randomly dispersed without beginning or end, without any relationship between cause and effect. We know that Flaubert has been represented as both the pope of naturalism and the champion of art for art's sake. But naturalism and art for art's sake are simply unilateral ways of referring to one and the same thing – i.e., this intertwinement of two logics which is the presence of one art in another.

If we return to Walker Evans's photograph, we can understand the photographer's reference to the novelist. This photograph is neither the raw record of a social fact nor the composition of an aesthete engaged in art for art's sake at the expense of the poor farmers whose misery he is to display. It marks the contamination of two arts, two ways of 'making us see': literary excess, the excess of what words project over what they refer to, haunts the photography of Walker Evans, just as pictorial silence haunts Flaubert's literary narration. The power of transformation of the banal into the impersonal, forged by literature, comes to hollow out the seeming obviousness, the seeming immediacy, of the photo from within. The pensiveness of the image is then the latent presence of one regime of expression in another. A good contemporary example of this pensiveness might be the work of Abbas Kiarostami, which is poised between cinema, photography and poetry. We are familiar with the importance roads assume in his films. We also know that he has devoted several series of photographs to

them. These images are paradigmatically pensive images by the way in which they conjoin two modes of representation: the road is a route leading from one point to another; conversely, it is a pure trail of abstract lines or spirals on a territory. His film *Roads of Kiarostami* contrives a remarkable transition between these two kinds of road. The camera first of all seems to run through the artist's photographs. Since he is filming colour photographs in black-and-white, it registers their graphic, abstract character; it transforms the landscapes photographed into drawings or even exercises in calligraphy. But at a certain point the role of the camera is reversed. It seems to become a slicing instrument that rips up these surfaces similar to drawing paper and returns these graphic designs to the landscape from which they were abstracted. Thus, film, photography, drawing, calligraphy and poetry blend their powers and exchange their peculiarities. It is no longer simply literature that constructs its imaginary becoming-painting, or photography which evokes the literary metamorphosis of the banal. It is regimes of expression that intersect, creating unique combinations of exchange, fusion and distance. These combinations create forms of pensiveness of the image that refute the opposition between *studium* and *punctum*, between the operative character of art and the immediacy of the image. The pensiveness of the image is not then the privilege of photographic or pictorial silence. This silence is itself a certain type of figurativeness, a certain tension between regimes of expression which is also a set of exchanges between the powers of different media.

This tension can then characterize modes of production of images whose artificiality *a priori* seems to prohibit any pensiveness on the part of the sentence, painting or photograph. I am thinking here of the video image. When video art was

developing in the 1980s, some artists conceived the new technique as a resource for an art released from any passive submission to the spectacle of the visible. In fact, visual material was no longer produced in it by printing a spectacle on a piece of film, but through the action of an electronic signal. Video art was to be the art of visible forms directly generated by the calculation of an artistic thought, disposing of an infinitely malleable material. Thus, the video image was no longer really an image. As one of the promoters of this art put it, 'Strictly speaking, there is no instant in time in which we can say that the video image exists.' In short, the video image seemed to destroy what accounted for the peculiarity of the image – i.e., its quotient of passivity resistant to the technical calculation of means and ends, as well as the appropriate reading of significations in the spectacle of the visible. It seemed to destroy the power of suspension peculiar to the image. Some regarded it as the resource of an art that was complete master of its material and its means; others saw in it the loss of cinematographic pensiveness. In his book *Le Champ aveugle*, Pascal Bonitzer denounced this surface that was malleable into perpetual metamorphosis. What was lost in it was the image's organizing breaks: film frame, unit of the shot, breaks between the inside and the outside, the before and the after, on-screen and off-screen, the near and the far. Consequently, it was also the whole affective economy bound up with these breaks that disappeared. Cinema, like literature, lived off the tension between a temporality of the sequence and a temporality of the break. Video made this tension disappear, in favour of an infinite circularity of the metamorphoses of docile matter.

The same has been true of video art as of photography. Its development contradicted the dilemma between anti-art and

radically new art. The video image has likewise been able to make itself the site of a heterogenesis, a tension between various regimes of expression. A characteristic work of these years helps us to understand this. Woody Vasulka's *Art of Memory*, made in 1987, is the work of an artist who at the time thought of himself as a sculptor manipulating the clay of the image. And yet this sculpture of the image creates an unprecedented form of pensiveness. The homogeneity of the material and the videographic treatment in fact lend themselves to several differentiations. On the one hand, we have a blend of two types of image. There are images that can be called analogical, not in the technical sense, but in the sense that they present us with landscapes and characters as they might appear in the eye of a lens or under the brush of a painter: a character wearing a cap, a sort of mythological creature who appears to us on the summit of a rock, a desert setting whose colours have been tampered with electronically, but which nevertheless presents itself as the analogue of a real landscape. Alongside, there is a whole series of metamorphic forms that are explicitly presented as artefacts, productions of calculation and machinery. In their form they appear to us as soft sculptures; in their texture as entities made out of pure light vibrations. They are like electronic waves, pure wavelengths corresponding to no natural form and without any expressive function. Yet these electronic waves undergo a dual metamorphosis that makes them the theatre of an unprecedented pensiveness. First of all, the soft form tautens into a screen in the middle of the desert landscape. On this screen we see projected some typical images of the memory of a century: the mushroom cloud of the Hiroshima bomb or episodes from the Spanish Civil War. But by means of video processing, the screen-form undergoes a further metamorphosis. It becomes the mountain path through

which fighters pass, the cenotaph of dead soldiers, or a rotary press from which portraits of Durutti emerge. The electronic form thus becomes a theatre of memory. It becomes a machine for transforming the represented into representative, the support into subject, the document into monument.

However, in carrying out these operations, this form refuses to be reduced to the pure expansion of metamorphic matter. Even when it is made a prop or theatre of action, it continues to act as a screen, in both senses of the term. The screen is a surface of manifestation, but it is also an opaque surface that prevents identifications. Thus, the electronic form separates the grey images of the archive from the coloured images of the Western landscape. It therefore separates two regimes of analogical image. And, by separating them, it divides its own homogeneity. It excludes the pretension of an art where artistic calculation is precisely translated into visible matter. The pensiveness of the image is this distance between two presences: the abstract forms generated by the electronic paintbrush create a mental space where the images and sounds of Nazi Germany, the Spanish Civil War or Hiroshima receive the visual form that corresponds to what they are for us: archival images, objects of knowledge and memory, but also obsessions, nightmares or nostalgia. Vasulka creates a cerebral memorial space and, by lodging in it the images of the century's wars and horrors, excludes debates on the unrepresentable motivated by mistrust of the image's realism and its emotional powers. But, conversely, the events of the century wrest the video from the dream of the idea engendering its own matter. They submit it to the visual forms in which they are preserved and constitute a collective memory: films, screens, books, posters or monuments. The pensiveness of the image is then the relationship between two operations that puts the unduly

pure form or the event over-charged with reality outside them-
selves. On the one hand, the form of this relationship is
determined by the artist. But on the other, it is the spectator
alone who can fix the measure of the relationship; it is exclu-
sively her gaze that imparts reality to the balance between the
metamorphoses of computer 'matter' and the staging of the
history of a century.

It is tempting to compare this form of pensiveness with that
brought into play by another monument erected to the history
of the twentieth century by video – Godard's *Histoire(s) du
cinéma*. Godard certainly proceeds quite differently from
Vasulka. He does not construct any memory machine. He
creates a surface on which all images can slide into one
another. He defines the pensiveness of images by two key fea-
tures. On the one hand, each assumes the appearance of a
form, an attitude, an arrested gesture. Each of these gestures in
a way retains the power Balzac conferred on his marquise –
that of condensing a story into a painting – but also that of trig-
gering another story. Each of these snapshots can then be
peeled off its particular support, slid into another or be coupled
with another: the film shot with the painting, the photograph or
the news clip. This is what Godard calls the fraternity of meta-
phors: the possibility that a face drawn by Goya's pencil can
be associated with the composition of a shot or with the form
of a body tortured in the Nazi camps captured by the photo-
graphic lens; the possibility of writing the history of the
century in many ways by virtue of the dual power of each
image – that of condensing a multiplicity of gestures signify-
ing a time and that of being combined with all those images
endowed with the same power. Thus, at the end of the first
episode of *Histoire(s)* the young boy from Seurat's *Bathers at
Asnières*, or the walkers from *Un dimanche après-midi à l'île*

de la Grande Jatte, become the face of France in May 1940, the France of the Popular Front and paid holidays, stabbed in the back by a Nazi Germany symbolized by a police raid drawn from Fritz Lang's *M*. After this, we see newsreel footage of tanks pushing into impressionist landscapes, while shots taken from films – *Die Niebelungen: Siegfried*, *The Testament of Dr. Mabuse*, *To Be or Not to Be* – turn up to show us that film images had already foreshadowed the forms of what were to become, with the war and the death camps, news images. I shall not return to the analysis of Godard's procedures.[6] What interests me here is the way in which he employs the labour of the figure on three levels. First of all, he radicalizes the form of figurativeness that consists in intertwining two logics of sequence: each element is articulated with each of the others in accordance with two logics – that of the narrative sequence and that of infinite metaphorization. At a second level, figurativeness is the way in which several arts and several media come to exchange their powers. However, at a third level it is the way in which one art serves to constitute the imaginary of another. With cinema images, Godard wants to do what cinema itself has not done, because it betrayed its vocation by sacrificing the fraternity of metaphors to the business of stories. By detaching metaphors from stories in order to fashion a different 'history' out of them, Godard fashions the cinema that has not existed. But he does so by means of video montage. On the video screen, with the resources of video, he constructs a cinema that has never existed.

6 I permit myself to refer readers to the analyses I offered in *Film Fables*, trans. Emiliano Battista, Oxford and New York: Berg, 2006, and *The Future of the Image*, trans. Gregory Elliott, London and New York: Verso, 2007.

This relationship of one art to itself via the mediation of another might provide a provisional conclusion to this reflection. I have tried to impart some content to the notion of pensiveness that refers to something in the image which resists thought – the thought of the person who has produced it and of the person who seeks to identify it. By exploring some forms of this resistance, I have sought to show that it is not a constitutive property of the nature of certain images, but a set of distances between several image functions present on the same surface. We then understand why the same set of distances is offered both in art and outside it; and how artistic operations can construct these forms of pensiveness in which art escapes itself. This problem is not new. Kant had already pointed to the distance between artistic form, the form determined by the intention of art, and aesthetic form, the form that is perceived without a concept and declines any idea of intentional purpose. Kant called those inventions of art that are capable of making this connection between two 'forms', which is also a leap between two regimes of sensible presentation, aesthetic ideas. I have tried to think about this art of 'aesthetic ideas' by expanding the concept of 'figure', to make it signify not only the substitution of one term for another but the intertwining of several regimes of expression and the work of several arts and several media. A number of commentators have wished to see in the new electronic and computer media the end of the otherness of images, if not the end of the inventions of art. But the computer, the synthesizer and new technology as a whole have no more betokened the end of the image and art than did photography or cinema in their day. The art of the aesthetic age has never stopped playing on the possibility that each medium could offer to blend its effects with those of others, to assume their role and thereby create new

figures, reawakening sensible possibilities which they had exhausted. The new technologies and aids supply these metamorphoses with unprecedented possibilities. The image is not about to stop being pensive.

Acknowledgements

The texts collected here represent the latest incarnation of talks whose earlier versions, revised several times, were presented in French or English at a variety of academic, artistic and cultural institutions over the past four years.

For their contribution to this book, I thank all those who invited and welcomed me and discussed a version of these texts in the following institutions: the fifth Internationale Sommerakademie at Frankfurt-on-Main (2004); SESC Pompéia in São Paulo (2005); École nationale des beaux-arts de Lyon (2005); CAPC of Bordeaux (2005); the Home Works festival in Beirut (2005); the French Institute of Stockholm (2006); the University of Amsterdam (2006); the Second Moscow Biennale of Contemporary Art (2006); the Summer University of Cuenca (2006); Fundação Serralves in Porto (2007); Zürcher Hochschuhle der Künste (2007); the Bozar Palace for Fine Arts of Brussels (2007); Pacific Northwest College of Art in Portland (2008); MUMOK in Vienna (2008); Stockholm University in Södertörn (2006); Trondheim University in Paris (2006); the University of Copenhagen (2007); Williams College in Williamstown (2007); Dartmouth College in Hanover (2007); the European University at St Petersburg (2007); the University of Basel's Eikones Centre (2007); the University of California, Irvine (2008); the

University of British Columbia, Vancouver (2008); and the
University of California, Berkeley (2008).

'The Emancipated Spectator', Chapter 1, appeared in its origi-
nal English version in *Artforum* 45:7, March 2007.

An English version of 'The Misadventures of Critical Thought'
was published in *Aporia: Dartmouth's Undergraduate Journal
of Philosophy*, autumn 2007.

A first version of 'Aesthetic Separation, Aesthetic Community'
appeared in *Art and Research: A Journal of Ideas, Contexts and
Methods* 2:1, summer 2008.

The reflection on the pensive image owes much to the seminar
held in 2005–06 at the Jeu de Paume Museum.

Finally, the author and publisher would like to thank Josephine
Meckseper, Martha Rosler, Alfredo Jaar, Rineke Dijkstra,
Sophie Ristelhueber, Sylvie Blocher and Pedro Costa, who
kindly allowed us to reproduce their work to illustrate this
book.

Printed in the United States
by Baker & Taylor Publisher Services